IMAGES
of America

EUSTIS

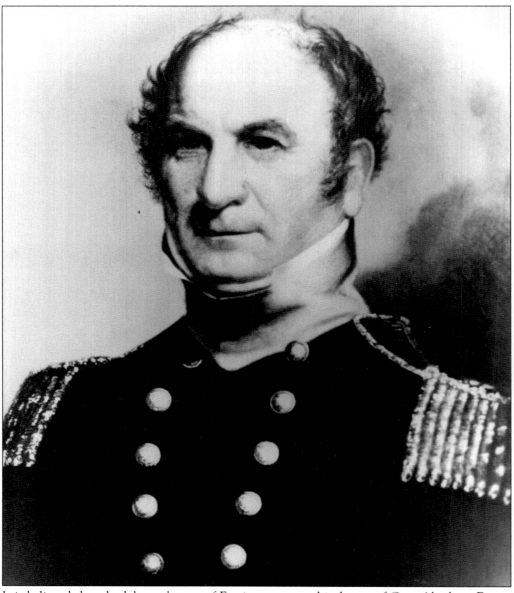

It is believed that the lake and town of Eustis were named in honor of Gen. Abraham Eustis. In 1838, while serving in Saint Augustine, he was sent into this area to clean up any renegade activity and make the area safe for settlement. He and his troops camped at Fort Mason, a few miles north of the present town, while awaiting the construction of a crossing over the flooded Ocklawaha River.

ON THE COVER: This photograph, taken February 22, 1912, during the boat parade for the Washington's Birthday Celebration, shows the thriving town of Eustis in the background. From its earliest beginnings, the town was focused on commerce and visitors at the waterfront. Steamboats provided a means for transporting citrus and agricultural products to northern cities.

IMAGES
of America

EUSTIS

Ruth Downs Akright and
Betty Slaven McClellan
on behalf of the
Eustis Historical Museum and Preservation Society

ARCADIA
PUBLISHING

Published by Arcadia Publishing
Charleston, South Carolina

Printed in the United States of America

Library of Congress Control Number: 2010935477

For all general information, please contact Arcadia Publishing:
Telephone 843-853-2070
Fax 843-853-0044
E-mail sales@arcadiapublishing.com
For customer service and orders:
Toll-Free 1-888-313-2665

Visit us on the Internet at www.arcadiapublishing.com

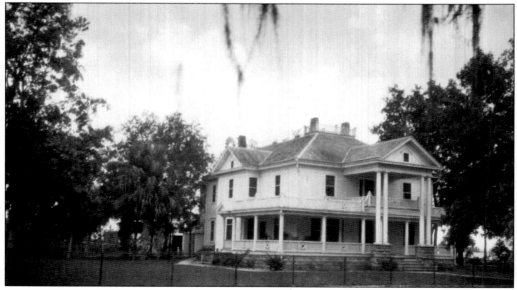

Guilford Clifford built this home on the shore of Lake Eustis in 1910–1911. An original settler and a true entrepreneur by the 1880s, he established a thriving hardware and building supply business. Placed in the National Register of Historic Places in 1975 by his daughter Lottie Taylor, just two months before her death at the age of 103, it is the home of the Eustis Historical Museum and Preservation Society.

CONTENTS

ACKNOWLEDGMENTS

This book has been a labor of love born of a shared love of history and place by the authors who had lost track of each other for nearly 50 years. Growing up together in Eustis, they were friends and classmates who moved on to separate lives, families, and careers. The opportunity to collaborate on this book has reunited them and rekindled their love and interest in their hometown.

The authors wish to express their sincere appreciation to Timothy Totten and the Board of Directors of the Eustis Historical Museum and Preservation Society for their support of the project. We would also like to thank the many other individuals who generously offered their knowledge and support. They include the Eustis High School Class of 1959, Lavonda Morris of the Lake County Historical Society and Museum, Robert Hauser, John Retey, Louise Carter, Maxine Green, Donald Porter Sr., David Porter Sr., David Porter Jr., and all the citizens of Lake County who recognize the importance of preserving local history. We would like to express appreciation to them for their donations of family memorabilia, written history articles, letters, and photographs that will ensure the unique history of the area is available for generations to come.

Unless otherwise noted, all of the photographs used in the book are from the collections of the Eustis Historical Museum. Those generously donated by Porter's Photo and others are so noted.

The authors dedicate the book to their families and friends, without whom we could not have completed the project. Special thanks go to Ruth's daughters, Dee and Brooke Akright and Kate Nabors, for their editing and help in compiling information. Betty Ann wants to thank Tammy Lynn Morris, her son DeVere Morris, and her daughter Bunnie Hibbard for their support, and remember the late Annette Bruce, who shared many wonderful stories of Eustis with her.

INTRODUCTION

Lake Eustis first appeared on a map created in 1823. It shows a large lake at the end of the Ocklawaha River. The lake, and the town that grew on its shores, was presumably named in honor of Brevet Gen. Abraham Eustis, a hero of the Seminole Wars.

With the passing of the Indian Removal Act by the US Congress in 1830, attacks by Seminoles increased on new settlers and their plantations. General Eustis and his troops began a journey from the Saint Johns River in Volusia County toward Fort Brooke, today known as Tampa, where along the way they encountered hostile Indians. When they reached the Ocklawaha, they found that heavy rains had caused flooding and trees jammed the river, making it impossible to cross. During the days that Eustis's troops waited for the construction of a bridge to cross the river, a camp was formed, trenches were dug, and layers of pine logs were placed on top. (Lottie Clifford Taylor, who, as a young child, was shown the area by her father, provided this description of the camp in her writings.) This camp on the northeast edge of Lake Eustis became known as Fort Mason. Fort Mason grew to a good-sized town and became the seat of the railroads that came to the area in the 1880s.

With the Land Settlement Act in 1860, Florida was opened for settlers. John A. MacDonald, a land agent in Jacksonville, began to advertise in the north enticing new settlers seeking a warmer, healthier climate and cheaper land to the Highland area, which was located in the central part of the state's sandy ridge around Lake Eustis. Here were less swampy lands, high hills, sandy soil, and remarkable trees that produced fruit known as citrus. In the late summer of 1875, for the sum of $10 each, MacDonald guided Guilford Clifford, Augustine Gottshee, E.F. King, P.P. Morin, a Mr. Level, Charles T. Smith, and a Mr. Conway to an area where they could purchase land and establish new homes. The men traveled by steamboat from Jacksonville down the Saint Johns River to Melonville Landing, which is known as Sanford today. The 60-hour boat trip through the peaceful countryside with huge cypress trees and the breathtaking beauty of nature was only the first leg of the trip. From there, the men began another 16-hour, 30-mile trip westward with a hired wagon drawn by two small ponies. There were no roads as they traveled over a sandy, root-burdened path with creeks and palmetto marshes. They arrived late on a rainy evening at the home of Dr. W.P. Henry, who appears to have been the area's first settler. The next morning, the men were shown the available property and made their purchases at the cost of $1.25 an acre. John MacDonald later settled in Eustis and became the first mayor in 1883 when the town was incorporated.

All of these early pioneers remained and began to build a new town except Mr. Conway. Clifford soon built a two-room cabin on his 160 acres along the west edge of Lake Woodard. One room was used for a store and the other for family living. Today, this area is near the southern city limits of Eustis. Several months later, Clifford brought his wife, Unity Bell, and their young daughter Lottie to his new property. He later purchased more land and, in 1881, built a larger mercantile store on the east side of Lake Eustis. Gottshee settled east of Lake Woodward. Morin made his

homestead north and east of a lake he named Nettie. Charles T. Smith made his home east and south of Lake Saunders and, later, became a partner in a mercantile store with Clifford. E.F. King selected land that now includes Hanman Heights. A.S. Pendry, who came in 1876, founded his homestead in the central area of Eustis where he built a hotel to be named the Ocklawaha. In 1877, the first trees fell as construction began on the hotel located on the west side of Lake Gracie, named for Pendry's daughter.

The community's name changed several times over the years from Pendryville, Highlands, and Lake Eustis, until the word "Lake" was dropped in 1883. The growth around the lake's east side continued, with stores and businesses developing in what became the downtown area. Roads were kept passable for travel by adding pine straw to the sand bases, and wooden sidewalks were installed to help pedestrians shop at the stores in town. The telegraph arrived in 1878. In 1882, the Saint Johns and Eustis Railroad arrived to serve Eustis's two depots, one for freight and the other for passengers.

Growing from the early seedlings found by the pioneers, large citrus groves surrounded the community and soon became the main industry for the area. The first United States citrus agricultural research station was established in Eustis by the Department of Agriculture in 1892. The scientists studied citrus diseases and progressed to research on plant hybridization. Despite the hard freezes in the winter of 1894–1895 that killed thousands of trees and severely impacted the economy of the town, by the mid-1900s, Eustis became known as the "Orange Capital of the World."

Tourism was Eustis's first industry and one that still brings as many as 20,000 visitors annually to the town. The many lakes, mild climate, temperate breezes, and varied recreations, such as hunting, boating, golfing, and tennis, make it a prime winter vacation spot. Beginning in 1902, the citizens and businesses started an annual festival held on February 22 to show their appreciation for the winter visitors. The Washington's Birthday Celebration is one of the oldest continuous festivals in the United States. With boat parades and races, hand-decorated automobiles and floats, numerous contests, bands, sailing regattas, and a grand parade down Bay Street, the day is one of great fun for all ages.

In the 21st century, the City of Eustis honors her past as she continues to grow. Today's visitor to the "Queen City by the Unsalted Sea" will find beautifully preserved historic landmarks, stately homes, family-owned businesses, and a newly constructed Lake Walk that offers a spectacular view of the lake that started it all.

One

PIONEERING IN THE HIGHLANDS

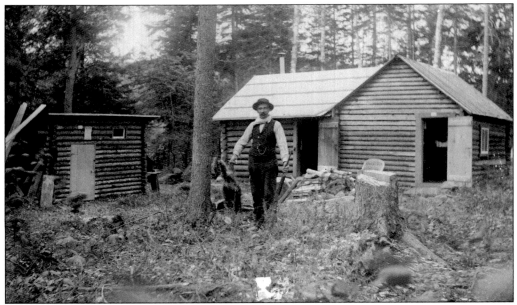

The temperate Highland area of Florida attracted new settlers like Guilford D. Clifford, pictured here in front of his c. 1875 house constructed on his original homestead on Lake Woodward. One room of the house was for family use, and the other was used as a store. Though the first homes were rough, they had glass in the windows and furnishings were brought from the north. Families arrived to share the new life in the developing town of Eustis.

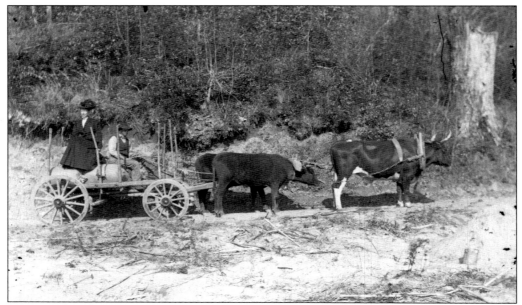

When settlers first arrived, travel over rough trails was difficult. Oxen teams pulled the heavy wagons that transported both passengers and freight to the area. By 1904, there were 40 miles of clay- or straw-surfaced roads that had a fireguard plowed on each side to prevent grass fires. In the 1900s, every voter had to give one day's labor on the public road in his precinct. (Courtesy of Porter's.)

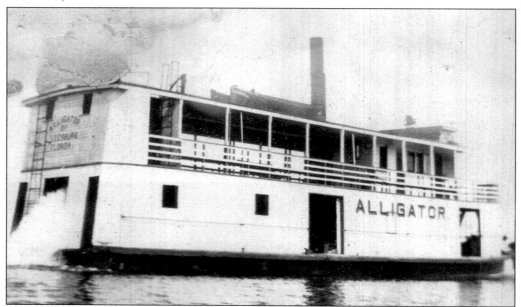

The *Alligator*, built in 1888, was one of many steamboats that brought passengers and freight into the Eustis Public Dock at the foot of Magnolia Avenue. The boat, originally equipped with a screw propeller, was later changed to a recessed, or inboard, stern wheel to accommodate the narrow turns and heavy vegetation of the Ocklawaha River the boat traversed on its way to Lake Eustis.

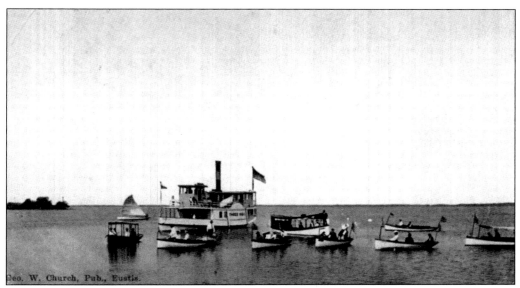

Capt. William Bennett Baker came to Eustis in 1895 and, shortly after, had a $10,000 side-wheel steamboat built as a pleasure craft by a Jacksonville boat builder. Named for his three grandchildren, the *Three Kids* operated from the Eustis dock at the foot of Magnolia Avenue, now Ferran Park, from the late 1890s until the early 1900s. On Lincoln's Birthday each year, he invited all visitors from Illinois to a boating picnic aboard the *Three Kids*. In 1901, the boat became unsafe for water travel, so it was sold for $350 to Capt. H.J. Hampton and moved to a lot on Bay Street where it was used as a home for many years. It later became a restaurant and gas station, known as the Dreamboat, until it burned in 1957. (Below, courtesy of the Lake County Historical Society and Museum.)

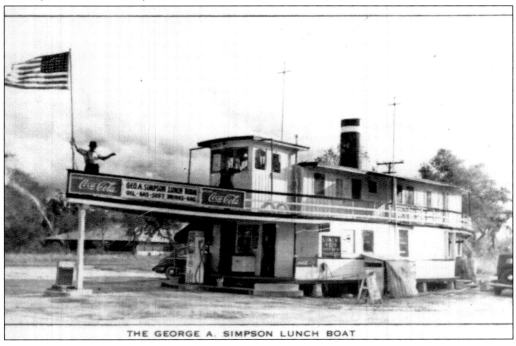

THE GEORGE A. SIMPSON LUNCH BOAT

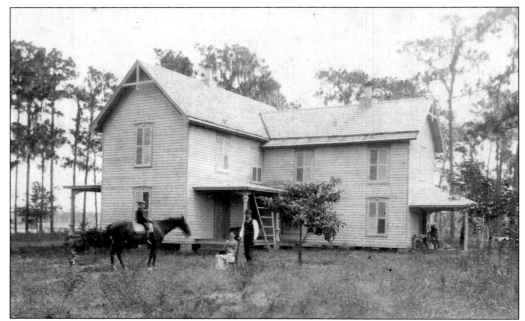

The Herrick family came to Eustis as early as 1876 and purchased land on the east side of Lake Eustis. Some of the family members were carriage makers who made buggies, buckboards, wagons, and log carts. Pictured here from left to right in front of this fine house are Luther Norman Herrick, Grace M. Herrick, and Norman Reeve Herrick Sr.

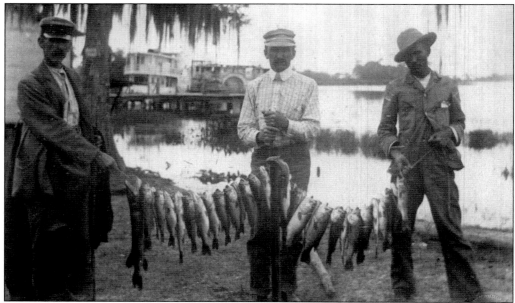

These men have had a fine day of fishing on Lake Eustis. This typical scene from the 1890s shows two steamboats tied up at the dock behind a large cypress tree. Bass, bream, perch, and catfish were caught from the lake. Fishing, hunting, boating, and excursions on the lake were among the attractions that brought winter tourists in large numbers from November to March. (Courtesy of the Lake County Historical Society and Museum.)

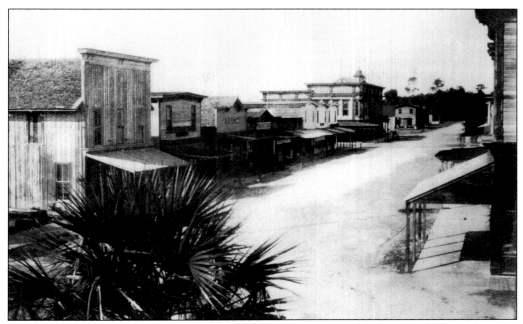

This 1890 photograph shows the west side of Bay Street in a view looking north from Magnolia Avenue. The street was just a wagon road of deep soft sand. Three buildings, built by John MacDonald, are shown. Druggist Guy Hutchings occupied two, and the third was in use by A.M. Dewitt. Guilford D. Clifford's store is at top right. (Courtesy of Porter's.)

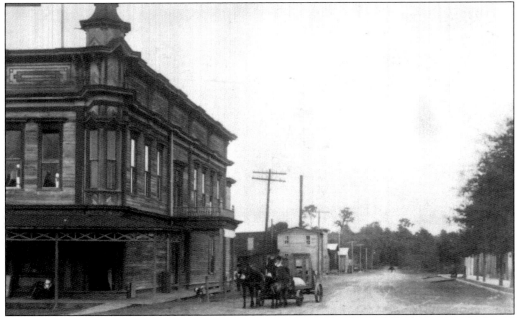

In this view of Bay Street from MacDonald Avenue looking north is Clifford's Store, which was built in 1881. Notice the wood sidewalks in front of the store. The second floor of the store held a hall in which church groups met and various community activities took place. Driving his mules past the store is Stin Haselton, who later owned one of the large dairies in town.

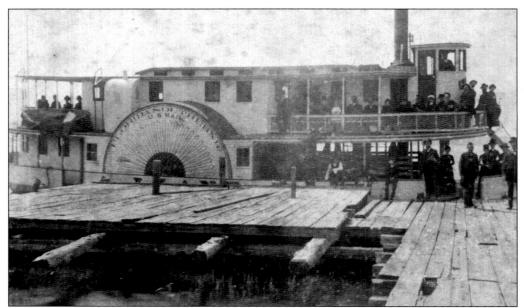

The *Florida Southern* US mail boat stopped in Eustis once a week beginning in 1878. Originally, mail was brought from Mellonville to the Smith Clifford store once a week. From there, it was sorted and placed in a small wooden box and nailed to a pine tree near where Mount Dora Road turns off Grove Street. The first real post office was at the corner of Grove Street and Citrus Avenue.

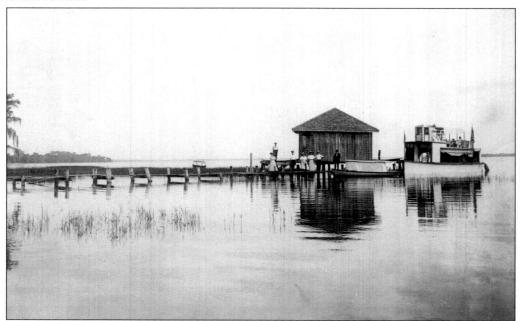

This tranquil scene shows a steamboat moored at a dock along the lakeside. In 1879, weekly steamboats came to Eustis via the Saint Johns River, through the Ocklawaha, and on to Lake Eustis. The boats brought needed supplies, including fertilizer, hay, and grain, from Illinois and Missouri. The landing here was the distributing point for goods to every town east of Eustis.

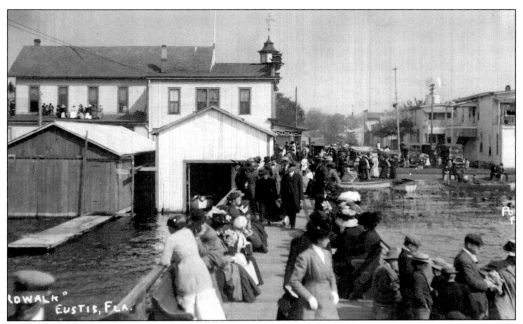

The boardwalk on Lake Eustis at the end of Magnolia Avenue, shown in this 1906–1910 photograph, was first called Johnson's Wharf and, later, City Pier. B.F. Vogt started the first newspaper, the *Semi-Tropical*, in one of these buildings in 1881. In the background are John MacDonald's office and the Round Building, a lunchroom owned by an African American family.

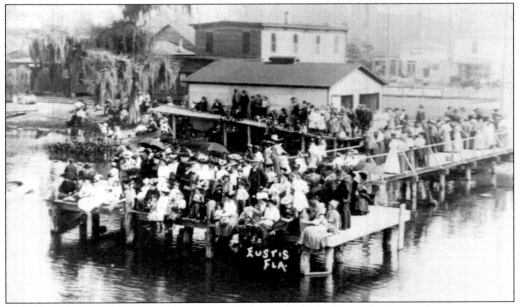

The Clyde Line and the Hart Line both called into the Lake Eustis docks to take on passengers and deliver freight. The trip from Jacksonville down the Saint Johns and Ocklawaha Rivers took two and a half days and cost $5. Shown are visitors in the early 1920s waiting to board one of these twice-weekly steamboats. The first boat to dock here was the steamboat *Nell* in December 1881.

Just before the turn of the 20th century, railroads came to Eustis to replace the oxcarts, wagons, and stagecoaches that had connected inland settlers and steamboat landings. They provided a fast, reliable method of transporting citrus products and local produce to northern markets. Above, a Saint Johns and Lake Eustis Railroad train is seen passing behind Charles T. Smith's business near Fort Mason. The railroad, a three-foot narrow gauge, was chartered in 1879 and ran 27 miles from Altoona to Eustis. It served as the land bridge for the boats that provided transportation into Florida's interior. By 1902, the line belonged to the Atlantic Coast Line Railroad. Stationmaster Robert Taylor managed the Atlantic Coast Line Railroad Depot, pictured below in 1898. Eustis had two depots, one for freight and one for passengers. (Both, courtesy of Porter's.)

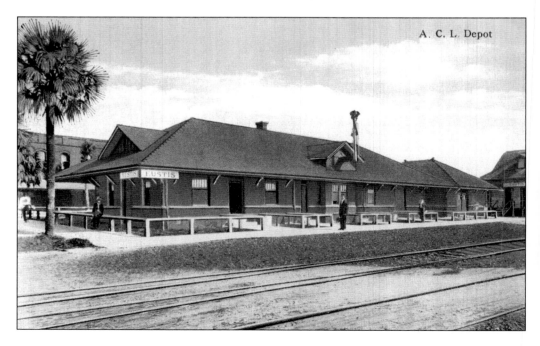

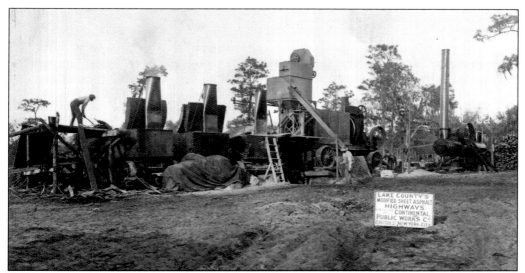

Between 1916 and 1918, the Dixie Highway came to Eustis. Part of a nationwide highway improvement plan, it came in from the northwest and went along the shore of the lake from Trout Run. The highway then ran south to Bates Avenue, North Bay Street, and onto Magnolia Avenue. Switching directions, it would briefly travel east to Grove Street and, finally, back south toward Mount Dora. The road was narrow and was sometimes paved with macadam or brick, but it was a great improvement over the sand-and-clay roads that existed before. It gave everyone access to town on a paved road. In the photograph above, Grove Street is paved, and concrete curbing is installed. The photograph below shows the Lake County Plant where the paving material was prepared. Mules and wagons delivered the tar to the worksite.

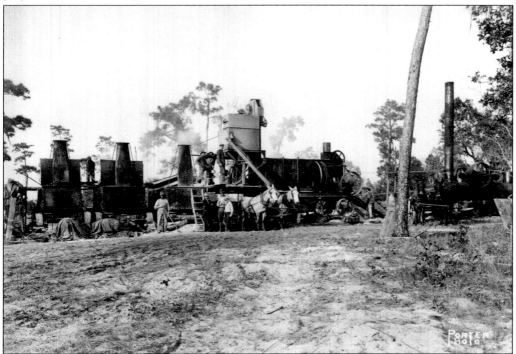

"Here she comes," may be what young Wayne Matthews is saying in this 1925 photograph. Fascinated by trains, he climbed the fence to watch them pass from the backyard of his grandfather Guilford Clifford's house at 536 North Bay Street. His attention was often divided between the rolling steel to the west and shining automobiles on the Dixie Highway to the east.

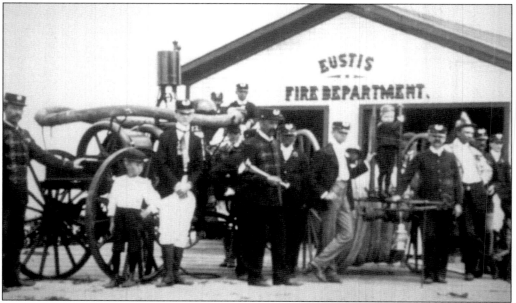

The Eustis Fire Department, formed in 1883, was noted for its efficiency and equipment. Its first hand-drawn ladder wagon, shown here, was put into service along with a supply of buckets, and served the town until a stationary gas engine pumper was purchased in 1900. It drew water by suction from the lake and fed into a main line that supplied the business section. (Courtesy of the Lake County Historical Society and Museum.)

Two

WINTER VISITORS

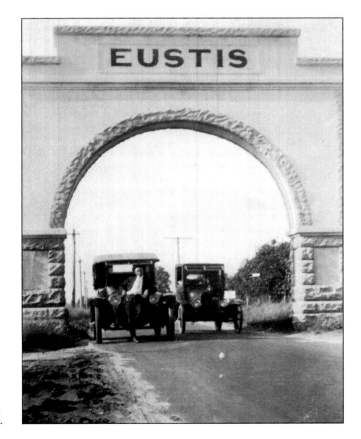

The Eustis Arch, believed to have been on South Grove Street, welcomed winter visitors and residents alike to the growing town. An 1887 edition of the *Florida Highland Press* reported, "Every train is now bringing tourists in large numbers and all the hotel men are happy." Shown in a 1916 photograph is Charles Conant, the driver for Margaret Choate.

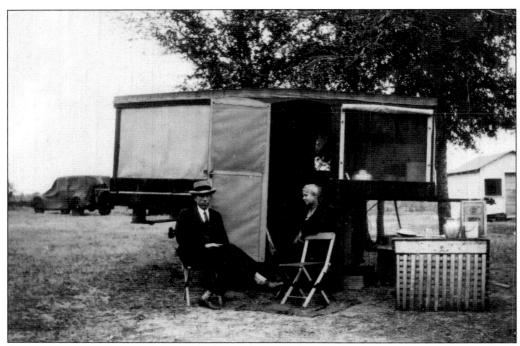

As transportation became easier with the production of automobiles, tourism grew as an industry in Eustis. Winter visitors flocked to the warm climate, and many stayed in cabin and trailer camps in the area. Examples included the Eustis Cabin and Trailer Camp, the Wagon Wheel, and the Eustis Fish Camp, which was on West Citrus Avenue. The visitors lived in tents and small trailers, like these pictured, while they enjoyed the numerous activities available to them, including fishing, hunting, boating, and many other types of recreation. By 1922, the city began building another "first-class, sanitary," free motor camp to accommodate the increasing number of visitors. Over the years, the camps continued to grow and prosper. By the late 1950s, the city began to schedule "tin can" rallies each year for the campers.

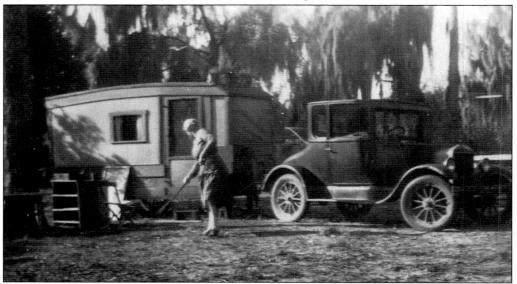

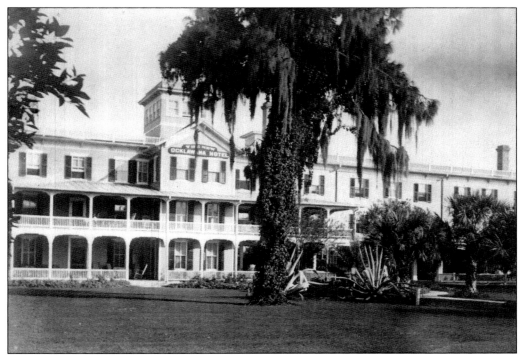

The first tourist accommodation in Eustis, the Ocklawaha Hotel, built by Augustus S. Pendry, began as a small hotel in 1878. Sold to John Lane in 1895, it was razed, and a new hotel was built. By 1908, it had grown to a first-class hotel that offered cottages, especially for families. Advertised to be modern in every appointment, the hotel was heated with steam, lighted with gas, and had telephones. (Courtesy of the Lake County Historical Society and Museum.)

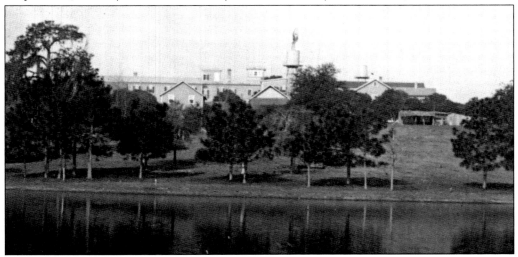

This 1908 view of the Ocklawaha Hotel, taken from across Lake Gracie, shows the vast size of the hotel and its ideal setting high above the lake. From its broad verandas and sun parlor on the roof, it offered the visitor unobstructed views of lakes, woods, and orange groves. Hotel-provided automobiles transported guests from the train depot. (Courtesy of the Lake County Historical Society and Museum.)

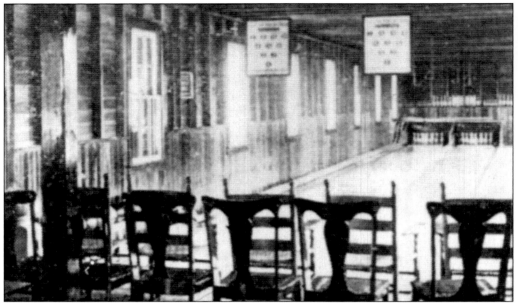

Shown is the bowling alley located in the Casino of the Ocklawaha Hotel, which was one of the many recreational facilities offered by the hotel to its guests. There was also tennis, croquet, billiards, and a children's playhouse. According to the *Lake Region News*, a clubhouse exclusively for women was erected on the hotel's golf links southwest of the hotel by 1916.

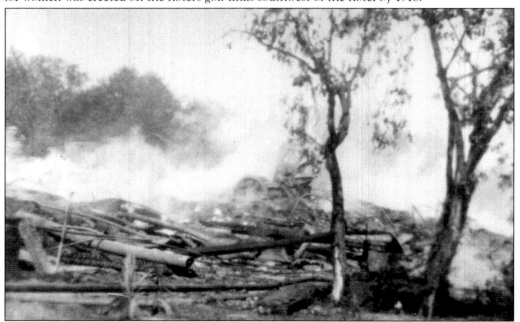

The magnificent Ocklawaha Hotel was totally destroyed on June 23, 1923, in a conflagration that could be seen for miles. This ended an era of luxury for tourists and residents alike. Gone was the Cuisine, a restaurant noted for its excellence and noted chef. Gone too was the grandeur and ambience that lured winter visitors back year after year for the fishing, golfing, boating, and hunting offered by the area.

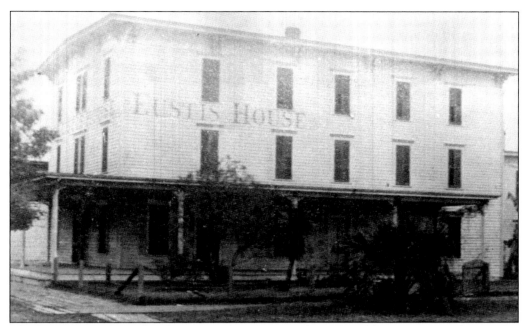

The Eustis House, located at the corner of Bay Street and MacDonald Avenue, opened in 1885. It had 35 rooms that were reported in a 1915–1916 tourism directory to be "neatly furnished and well ventilated." Guilford D. Clifford, John A. MacDonald, and Moses J. Taylor built and owned the hotel, located in the business portion of the town. Eva Power Bishop operated it at one time.

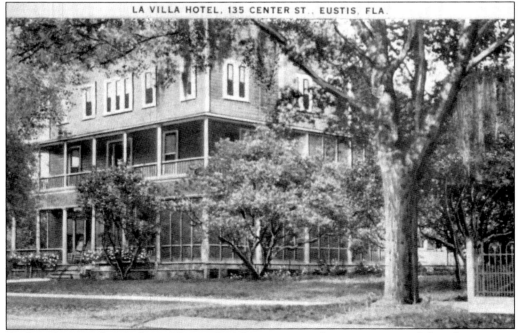

Arthur S. Van de Mark and his wife, Minnie, were the proprietors of the three-story, Victorian-style La Villa Hotel, which was at 135 South Center Street on the south side of the Presbyterian church.

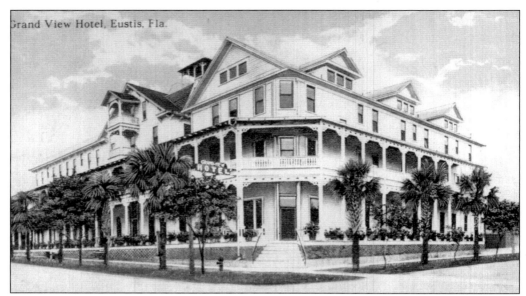

The high-Victorian Kismet Hotel, located on Lake Dorr, near Pitman, was dismantled and moved to the corner of North Grove Street and Magnolia Avenue in 1915. Reassembled and renamed the Grandview Hotel, it had 59 rooms and featured a broad two-story veranda and a dormered roofline.

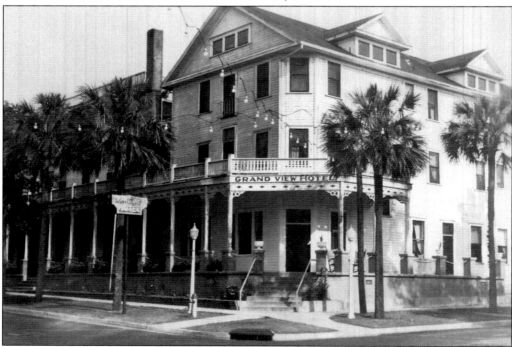

After suffering a fire on Thanksgiving Day 1930, the Grandview Hotel was repaired and reopened. Many of the Victorian-architectural elements of the building were altered, such as the upper and side porches and roofline. In this photograph, one can see the in-ground streetlight present at that corner. First State Bank & Trust bought the hotel in 1956 and demolished it to make room for a new bank.

The Spanish-style Fountain Inn opened on June 3, 1923, with 164 rooms with private baths. The first guests were 400 members of the State Pharmaceutical Association and their wives. Owned by Frank Waterman of New York City, the president of the Waterman Fountain Pen Company, the hotel offered visitors a worthy replacement for the lost Ocklawaha with its sun parlors, palatial lobbies, and dining rooms.

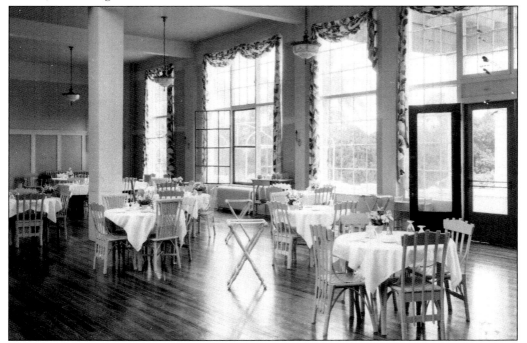

Shown is one of the very elegant dining rooms in the Fountain Inn Hotel. The tables were set with the finest china, crystal, silver, and linens. The lush window treatments framed the large windows overlooking the back lawn where patrons could stroll after dinner.

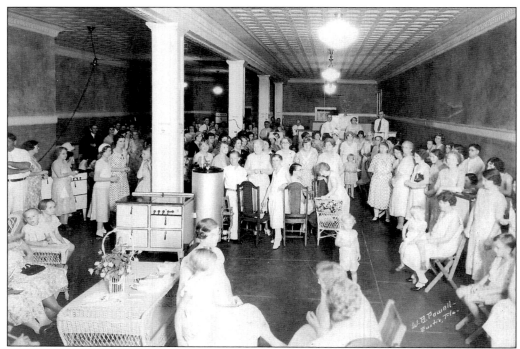

This photograph shows how well-attended this c. 1950 General Electric home appliance show held in one of the Fountain Inn Hotel ballrooms was. Louise Porter, who was the home extension agent for Lake County, was responsible for bringing such exhibitions to the area.

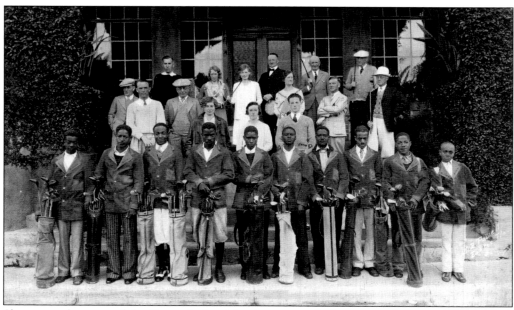

Shown on the steps of the Fountain Inn Hotel are some 1931 guests and their caddies as they prepare for a day on the fairways. Golf was a much more lively sport then, with clubs bearing names such as brassie, cleek, spoon, midmashie, and niblick.

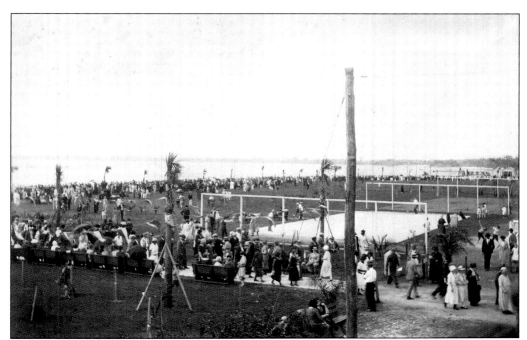

A large crowd is present as tennis courts join the numerous recreational facilities available for the public in Ferran Park along Lake Eustis, as shown in this photograph taken on the park's opening day in 1926.

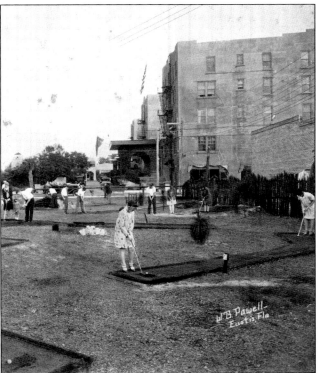

Tourists and local residents enjoy the 18-hole Country Club Junior Miniature Golf Course. The lighted course was one of the most popular in the United States. The Fountain Inn Hotel is seen in the background. The course was one of many designed and built by local businessman S.M. Brady, who also owned Brady's Dress Shop on Magnolia Avenue. (Courtesy of the Lake County Historical Society and Museum.)

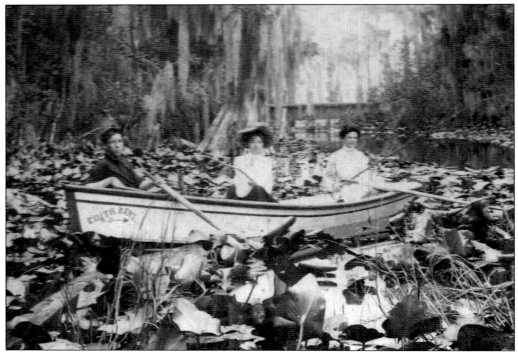

On lazy days, fishing and drifting along surrounded by cypress trees and lily pads on Lake Eustis were favorite pastimes enjoyed year round. Pictured from left to right are Tavares residents Leonard and Marie Duncan and an unknown female angler. (Courtesy of the Lake County Historical Society and Museum.)

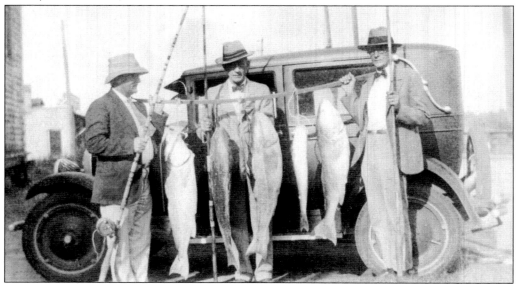

Tourists show off their day's catch of saltwater fish. The "good roads" movement, including the Dixie Highway, made it possible for fishermen, like those shown, to travel from Eustis to Daytona and the Atlantic Ocean. The trip over the newly paved roads was shortened from 107 to 51 miles. (Courtesy of the Lake County Historical Society and Museum.)

In 1904, a roof was added to the city docks, creating a pavilion and seating area over the waters of Lake Eustis. Dances, refreshments, and free band concerts were regularly held at the pavilion. In 1921, a bulkhead, which extended 250 feet into the lake, was built, and the pavilion was then repurposed as the home of the Tourist Club of Eustis/All States Tourist Club. In 1926, this bulk-headed area was named as a memorial to Edgar Ferran, a local businessman and Eustis pioneer. With the addition of a band shell and other amenities, Ferran Park has become the town's hub for entertainment. The photograph below was taken from a World War II–era early warning tower, which was formerly located in the park.

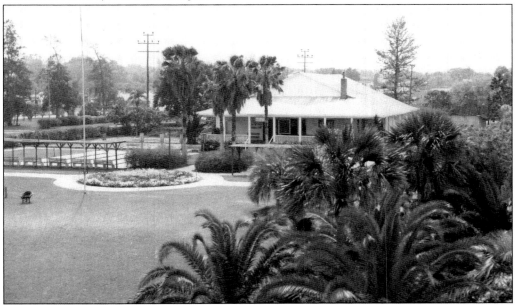

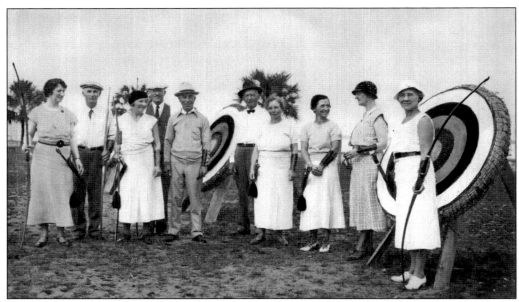

This 1930s photograph shows a group of archers in front of the bucks (targets) in Ferran Park on the shores of Lake Eustis. Sportsmen and women had a choice of many activities within the park, including shuffleboard, tennis, rogue, horseshoe pitching, and boating.

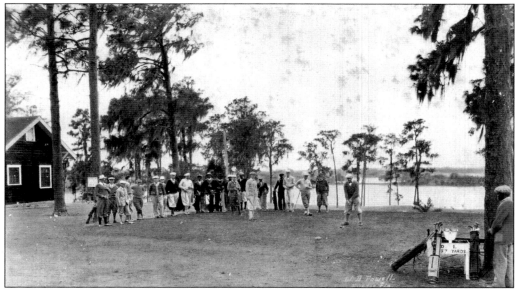

In the 1920s, the Lake County Country Club, offering an 18-hole course with greens fees of only $1, was considered to be the best course in the area. The 6,000-yard course on Lake Joanna was popular among tourists as well as local residents. A story recounts that some golfers once found a fairway flooded and apparently used their clubs to fish for gar. Did they perhaps use their midmashies? (Courtesy of the Lake County Historical Society and Museum.)

The well-dressed fisherman in this 1899 photograph is believed to be Luther Herrick, an early settler and businessman. Lake Eustis fishermen could expect to snag bass, bream, trout, and lazy old catfish. The lake also held soft shell turtles, considered a delicacy by some. They were included on the menu along with frog legs at the Green Tile Restaurant.

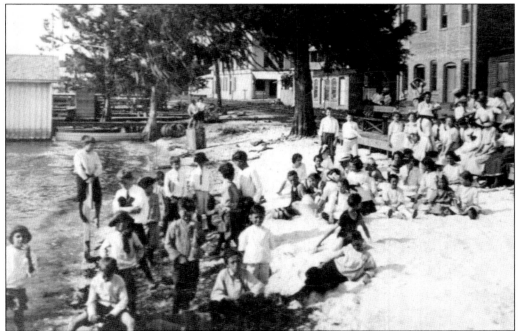

In this early 1920s photograph, children and adults are enjoying what appears to be a school outing on a white sandy beach at the end of Magnolia Avenue. The rear of the Arborio Building is visible behind the adults.

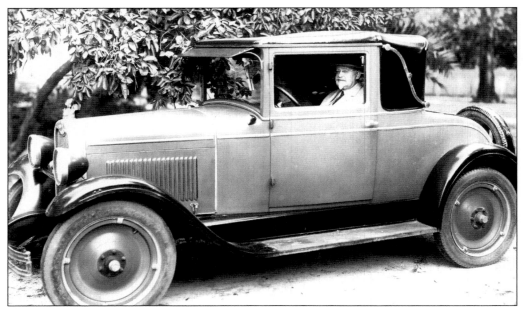

A winter visitor to Eustis, Dr. Lynch of Norfolk, Virginia, shows off his 1928 Chevrolet Sport Coupe with its Clencher tire rims. According to the US patent filed in 1904, the Clencher was utilized as a safety feature to insure against, "involuntary separation when inflated or deflated." They spread and had a latch and locking pin. Only in 1928 did Chevrolet use oval radiator badges, as seen here. (Courtesy of the Lake County Historical Society and Museum.)

This group photograph, taken in the Tourist Club, is a celebration of 50 years of marriage. It was one of many events that took place in the recreation center. The club is located on the east side of Ferran Park between Orange and Clifford Avenues. A sea wall and Lake Eustis surrounds the park on its west side. (Courtesy of the Lake County Historical Society and Museum.)

Tourists rest and relax on benches at the putting green on the lawn of the Fountain Inn Hotel.

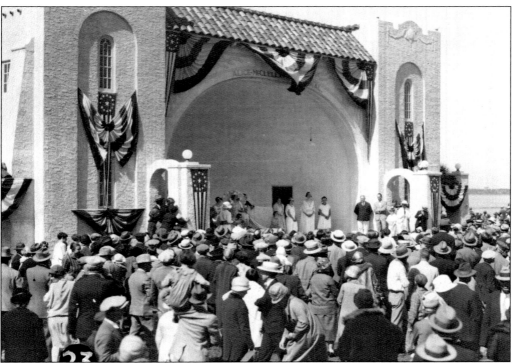

W.S. McClelland donated the Spanish-style Alice B. McClelland Memorial Band Shell in 1926 in memory of his wife. It was built on the west side of the park facing the town and was later moved to the north end of the park to improve the acoustics. Listed in the National Register of Historic Places, it is one of two surviving band shells in Florida. (Courtesy of the Lake County Historical Society and Museum.)

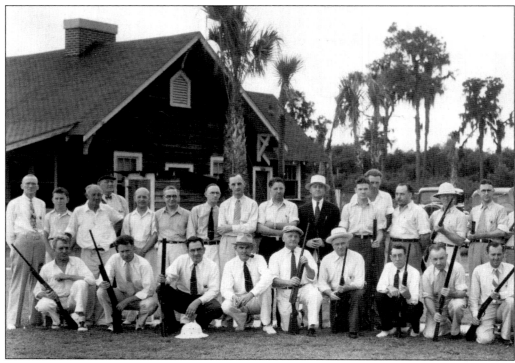

Here is the Eustis Gun Club of 1935–1936. Among those pictured in the photograph above are Carl Ferran, ninth from the left standing; J.R. Ashmore, fifth from the left kneeling; and Ansil Miller, seventh from the left kneeling. A trapshooting meet called the Winter Vandalia, pictured below, was held in Eustis in February each year. Sponsored by the Eustis Gun Club, the event took its name from meets that were held in Vandalia, Ohio. Entrants, including women, came from all over the United States to compete in these meets and to vie for 18 silver trophies. These meets were governed by the American Trapshooting Association and were divided into three classes. (Courtesy of the Lake County Historical Society and Museum.)

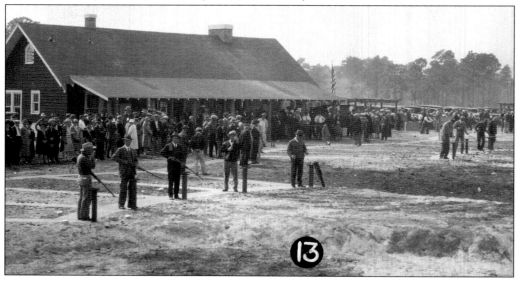

Three

THE HISTORIC ORANGE CAPITAL

By the mid-20th century, Eustis was known as the Orange Capital of the World. Despite the terrible losses in 1894–1895, the groves were once again flourishing, and fruit and juice were shipped worldwide. Many large packinghouses and processing plants were in operation. The economy was booming again. Today, sadly, many of the large groves are gone, and subdivisions have taken their place.

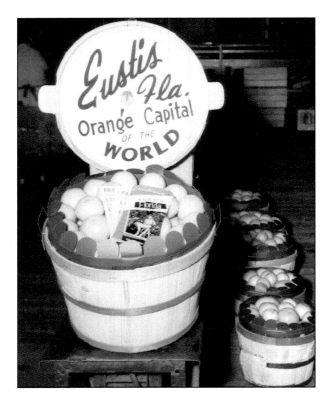

The United States Department of Agriculture Experimental Station was established in 1890 to study subtropical plant diseases. On land donated by Frank Savage, originally, the focus was on orange blight, but later, hybridization of fruits was perfected. Notably, the limequat, a cross of lime and kumquats, and tangelos, a tangerine-grapefruit mix, took their place as commercial citrus fruits. (Courtesy of the Lake County Historical Society and Museum.)

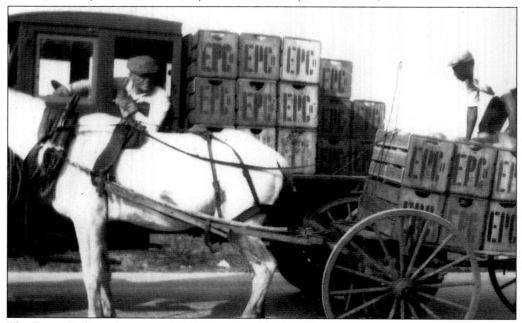

The Eustis Packing Company (EPC) was owned by Dougle M. Buie Jr., a 1936 graduate of Eustis High School. Before he purchased EPC, he was a fruit buyer for Barney Dillard at EPC for four years and then a fruit buyer for L.R. Huffstetler Company for six years. Buie was owner and president of the company for 32 years and spent more than 50 years in the fruit industry.

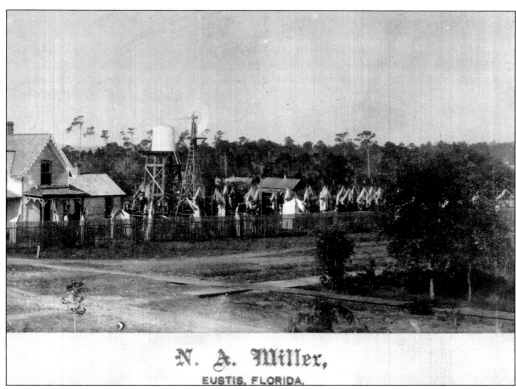

N. A. Miller,
EUSTIS, FLORIDA.

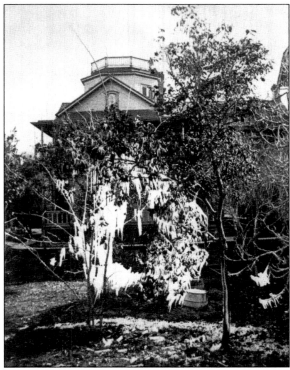

An account of the Big Freeze of the winter of 1894–1895, written by Lottie Clifford Taylor, talks of temperatures that reached as low as eight degrees. The tenting, shown above, was not enough to save the trees. Fruit and leaves all dropped from the trees. Taylor relates that after the first freeze in December, the weather warmed up and everything began to sprout again, so that the next blast in February took an even greater toll on the trees, splitting them and killing the roots. On February 12, their rain barrel was frozen solid, and trees dripped icicles. With the loss of the crop and trees as well as vegetables, many people gave up and moved away. Those who stayed were too poor to buy more than the necessities. Taylor's father offered credit at his store to anyone who needed it during this difficult time. (Courtesy of the Lake County Historical Society and Museum.)

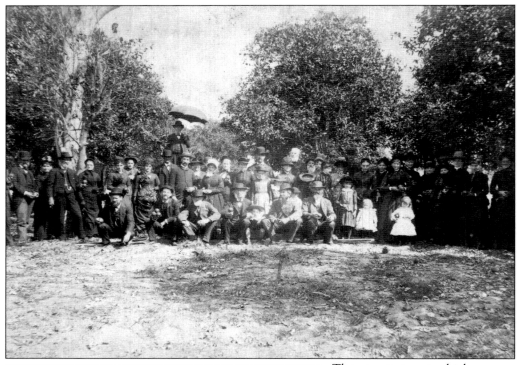

The orange groves, which were the focus of the community, give shelter to the grieving family of Luther Norman Herrick at his funeral at the Glenwood Cemetery. The name of the cemetery was changed to Greenwood in 1902 when previous owner Guilford Clifford sold it to the Cemetery Association.

William George Hauserman poses with his prize fruit in 1923. He owned a large citrus grove on the old Deland Road, east of Eustis. When his business failed, he returned to the north. Members of his family still live in the area.

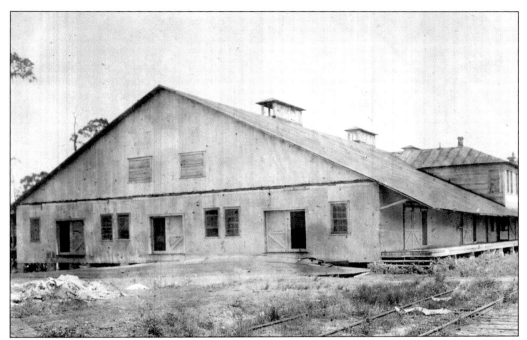

Standard Growers Exchange, located off Morin Street, was a full-service processing plant. Here, juice was made and canned, and pulp was converted into fertilizer. This plant later bottled and canned Shasta soft drinks. (Courtesy of the Lake County Historical Society and Museum.)

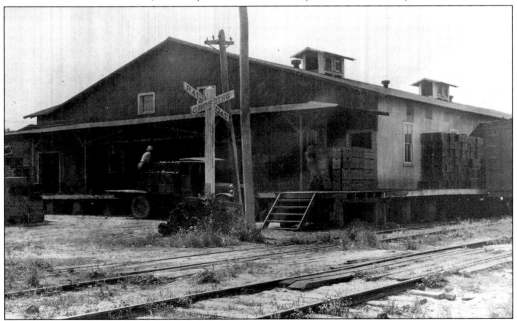

The Eichelberger Packing House, pictured here in 1935, was located at the corner of Eustis and Morin Streets. Owned by Joseph Eichelberger, it was one of the largest of the many citrus packing facilities in Eustis. The large groves that supported these houses have all but disappeared due to hard freezes that killed the trees and bankrupted many growers.

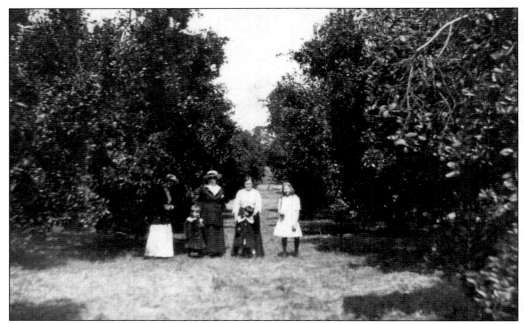

Members of the Choate family pose in their lime grove in 1915. The family produced lime juice under the label "Limecola," which was bottled in a block building behind their house and shipped as far away as Texas. Pictured are Margaret Shipley Choate, Corinne O'Dell, Connie O'Dell, Mabel ?, Mabel's daughter, and Virginia Choate.

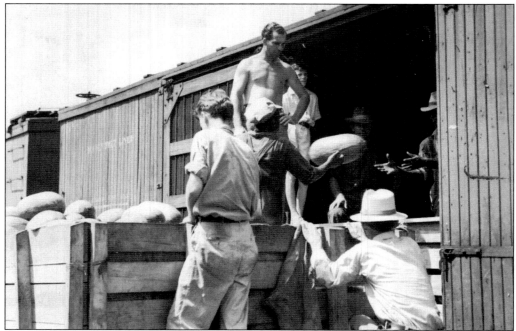

Seen here are local watermelons being loaded onto a train for shipment to the north. To avoid damage to the melons, they were sorted and packed with the larger ones on the bottom. B.G. Anderson Company was one of the leading melon producers in the area.

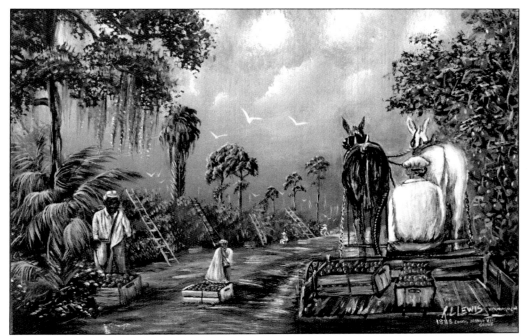

R.L. Lewis did four paintings for Eustis's 125th celebration. He was one of 26 African American artists from Fort Pierce who were known as "Highwaymen Painters." They traveled around the state in the 1950s and 1960s and sold their paintings from their cars. He created this depiction of the 1800s-era citrus industry. Pickers carried their fruit-filled bags to mule-driven wagons for transporting to local citrus processing plants.

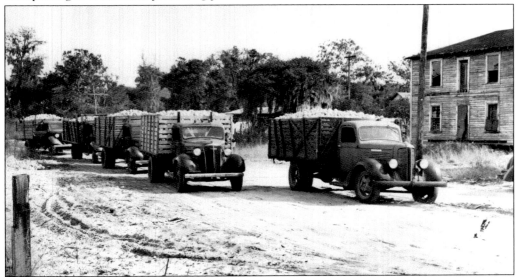

In a scene that was typical for Eustis in the early to mid-20th century, fruit arrives at a packinghouse in a caravan of trucks. The growers had to get the fruit to the processors before any freezes. Citrus ripened and sweetened just past the first cold spell. It was not uncommon to see fruit lying on the roadsides that had bounced from the often overloaded trucks. (Courtesy of the Lake County Historical Society and Museum.)

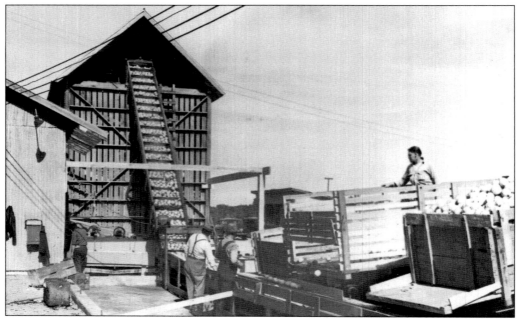

These photographs of Wegner Packing House, owned by W.F. Wegner of Sodus, New York, show some of the processing necessary to produce citrus juices. Above, the fruit is unloaded from trucks and travels up an exterior conveyor belt into the processing plant. It was not unusual to can two freight car loads in a single day. The cans were also unloaded onto automatic conveyors and went directly into the plant to be sterilized. Everything was done by machinery, and human hands never touched the contents. One man could fold and staple 450 boxes an hour. The plant was capable of canning half a million cases per year. After processing, the cans of juice moved along a conveyor belt, where they were packed into boxes and loaded on trucks for shipment to retailers. (Both courtesy of the Lake County Historical Society and Museum.)

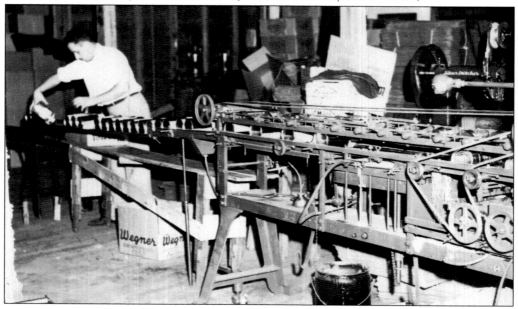

The operation of growing and processing "Florida Citrus" was truly a grass-roots family occupation for Dr. Chamber M. Tyre and his brother James. Dr. Tyre moved to Eustis in 1925 to start his medical practice, which lasted for 50 years. He was one of ten doctors who converted the failed Fountain Inn Hotel and founded Waterman Memorial Hospital. He also invested in movie theaters, groves, and cattle land. James B. Tyre Jr. moved to Lake County in 1926 and began purchasing and developing orange groves for the family. He operated the Tyre's Palm Terrace Fruit Company, near Mount Dora. Miss Atlanta–Atlanta Queen labels were used to promote their citrus at the Georgia Farmers' Market. (Glen Tyre contributed this history for his father and uncle.)

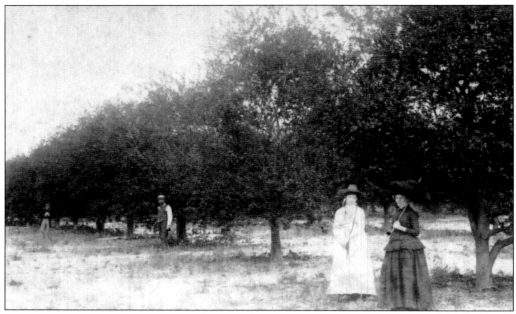

Albert D. Wright is pictured here (with white sleeves and white hat) with two unidentified ladies in his orange groves located in the southeast section of town. Wright served as a captain in the Pennsylvania 43rd United States Colored Troops during the Civil War and was wounded in the Battle of Crater. He was a member of the Eustis chapter of the Grand Army of the Republic and was active in the development of the town. He is buried in Eustis Greenwood Cemetery with a Medal of Honor marker.

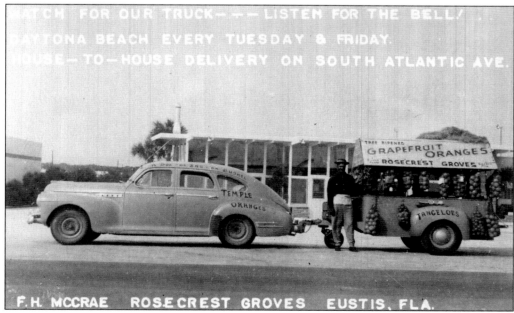

Local resident F.H. McRae made the trip to Daytona Beach every Tuesday and Friday with his portable fruit stand to sell a variety of fruit from Rosecrest Groves in Eustis. Many of the large groves and packinghouses set up stands on the roadsides to market their fruit.

This photograph, taken at Fort Mason, shows the large citrus processing plant located next to the Atlantic Coast Line railroad tracks, which are used to ship the products north. The tracks are still used to haul freight to Florida Foods and Golden Gem.

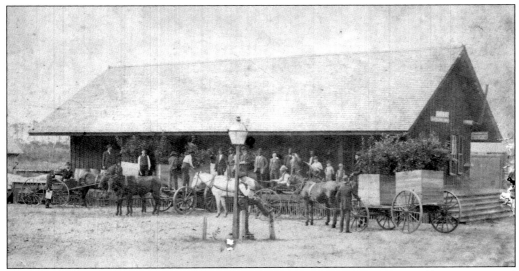

About 16 boxcar loads of nursery stock orange trees were shipped from Sunset Hill nursery, owned by G.D. Clifford, to Gulick Brothers in Riverside, California, in 1889. These were apparently starter trees for the citrus industry in Southern California. Many of the tender trees froze on the long rail trip. Railroad agent Robert Taylor is the man in the white shirt on the cart.

In 1926, Leslie Robert Huffstetler Sr. began working as a clerk for Eustis Packing Company and completed his business degree. He continued learning every aspect of the citrus industry, including the physical tasks, marketing, and harvesting. After working with Harris & Wade Packing Company, he purchased Eustis Packing Company and organized L.R. Huffstetler Inc. in 1949. He served on the Florida Labor Advisory Board and as director of Florida Orange Marketers. He remained an influence in the citrus industry until his death. He supported his community as three-time Eustis mayor and a member of the school board, the Waterman Medical Center's first board of trustees, and the Presbyterian church. He and his wife, Myra, were married for 64 years and had two children, Leslie R. Jr. and Ann. A label advertising Huffstetler as the "the oldest continuous fresh fruit shippers in Eustis" is pictured below. (Left, courtesy of Ann Huffstetler Rou.)

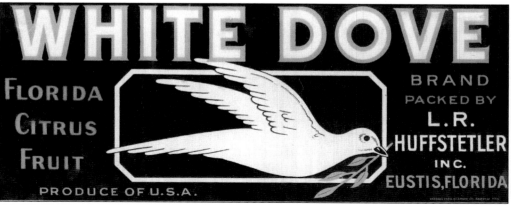

Four

WASHINGTON'S BIRTHDAY CELEBRATION

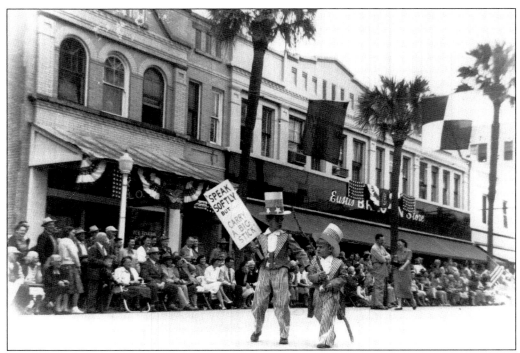

Washington's Birthday Celebration is recognized as Florida's oldest annual festival. A pageant portraying historic events from Florida's past was held at the Ocklawaha Hotel in 1902 in appreciation of winter visitors. The celebration has grown to include boat regattas, band concerts, a large parade, and various contests. Citizens take great pride is this annual event. Leading the 1955 parade are Bill and Eddie, sons of Harold and Jeanne Ferran.

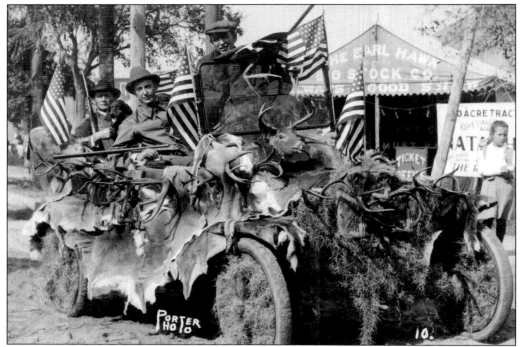

Participants in the Washington's Birthday Celebration parade have always been very creative and competitive in the decorations applied to their cars and floats. This deerskin-covered car entered into the 1916 parade is an excellent example.

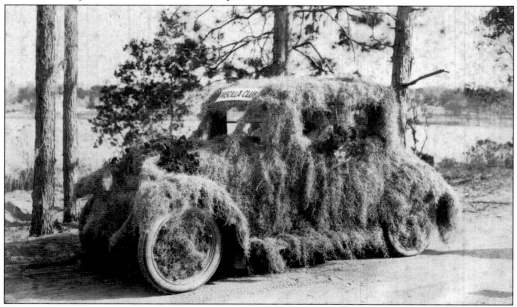

Spanish moss, a member of the bromeliad plant family, grows abundantly in the area. It has been a unique historic decorating material in city and school parades. The Priscilla Club entry, driven by Priscilla Bishop, utilized their choice of material to great effect as seen in this moss-covered car in 1925.

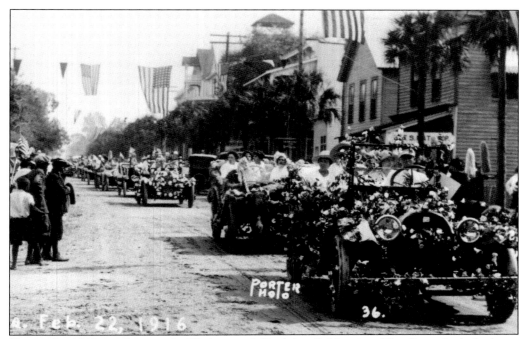

Here is the 1916 parade route for Washington's Birthday Celebration. The flower bedecked cars progress west on an unpaved Magnolia Avenue. In the background, the cupola and porches of the Grandview Hotel are clearly visible.

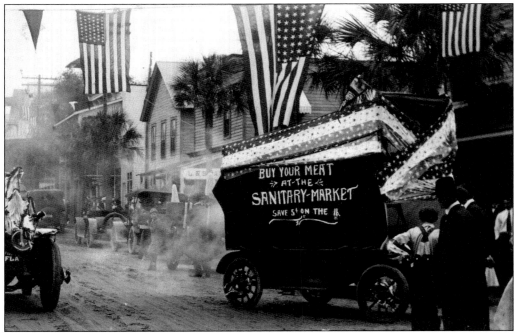

The Sanitary Meats entry in the 1916 parade advertises a 5¢ discount per pound. The truck is smoking and is pulled out of the parade line up. Perhaps the store will charge more now in order to make repairs to the engine.

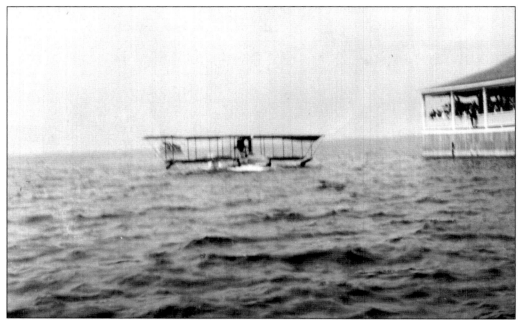

Antony Jannus, the first licensed airline pilot in the United States, taxis his new Benoist "airboat" Model XIV No. 43 toward the Eustis Pavilion for the celebration in 1914. Jannus was the pilot of the first commercial flight in the United States in January 1914, making the 25-minute flight from Saint Petersburg to Tampa.

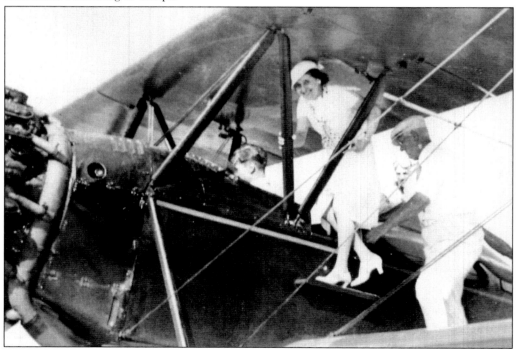

A tourist takes a plane ride during the 1924 Celebration. Dressed in her Sunday best, the adventurous woman prepares to board a biplane for a unique view of the "Unsalted Sea."

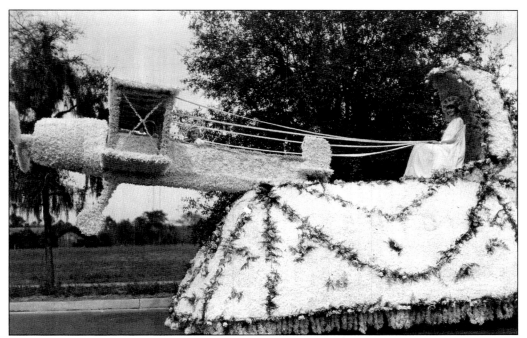

Eichelberger Packing House's float for the 1925 parade sports a model of a biplane decorated in tissue paper, asparagus fern, and flowers. Two unidentified little girls act as pilot and passenger in the plane, while a third controls the plane with a rein of ribbons.

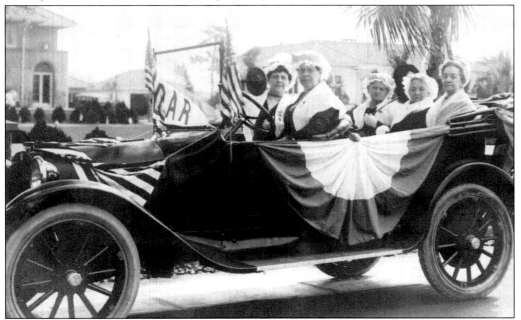

The 1918 Daughters of the American Revolution (DAR) parade entry was part of the DAR's convention held in Eustis that year. Their participation in the parade each year was just as dedicated and patriotic as their part in the activities of their organization. DAR is still an active civic organization today.

"George Washington" leads a 1924 float containing "Lady Liberty" and costumed children representing the states. The float is festively decorated with flags and bunting.

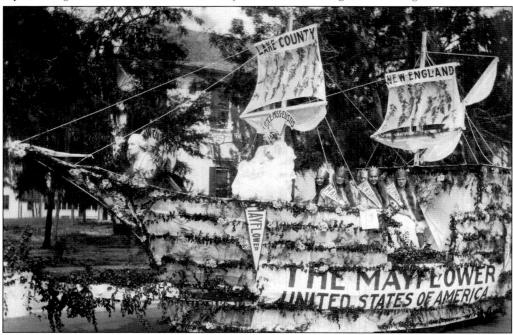

The *Mayflower* float of 1925 features Little Miss Eustis, Daphne Banks, at the age of six, sitting on the "forward deck" of the New England Tourist Club's entry. Daphne was the daughter of Dr. Edgar Banks and his wife Minja.

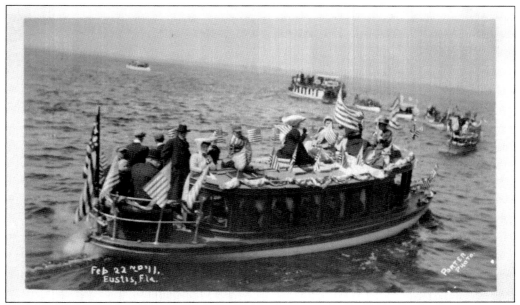

A rare photograph of the 1911 boat parade features ladies and gentlemen enjoying a windy day on the water. Boating and racing on Lake Eustis were hailed as some of the best in the state. As reported by Jeff Bailey of the 1925 regatta, "The boats are chug-chugging, put-put-putting along over the bosom of Lake Eustis, in a most vivacious cavortation. They chop up the old lake to pieces. The boats look snappy, they cut up and run like they were of the rabbit breed." The annual Eustis Regatta prompted the Lake County Yacht Club to order seven 18-foot racing sloops in 1923 to compete for the prize cup, donated by Sir Thomas Lipton, a five-time participant in the America's Cup. A long boat, pictured below, is filled to capacity in the 1918 parade.

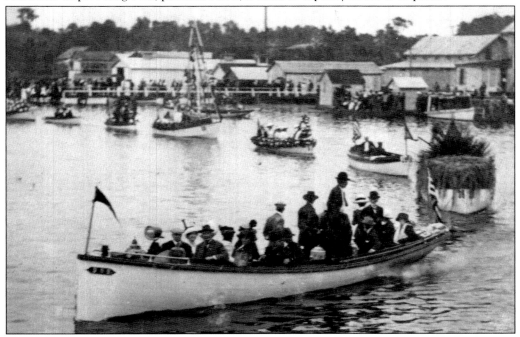

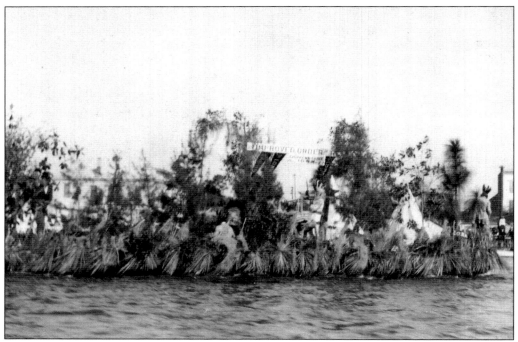

Believed to be the entry of a northern tourist club honoring the Chippewa Indians, this float in the boat parade is decorated with palmetto fronds and trees and represents a village scene. Although strong in numbers and occupying an extensive territory, the Chippewa were never prominent in history, owing to their remoteness from the frontier during the period of the Colonial wars.

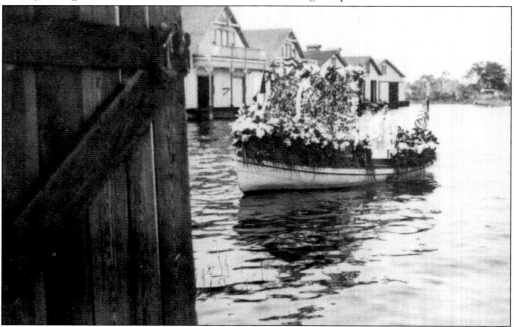

This 1918 photograph shows a beautifully decorated small boat as it sails past the boathouses on Dillard's Point in Lake Eustis. Some of these boathouses had apartments on the second floor.

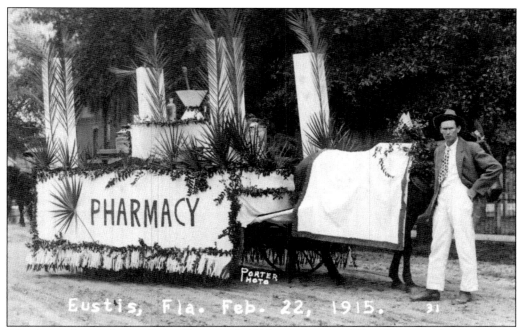

This horse-drawn float is Palm Pharmacy's 1915 parade entry. The pharmacy, located at the corner of Magnolia Avenue and Eustis Street, was operated by the Taylor family. The dwarf saw palmetto palm fronds featured are native to the south and are a dominant shrub in pine thickets and forests. (Courtesy of the Lake County Historical Society and Museum.)

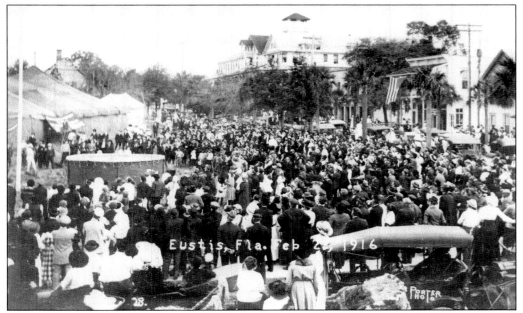

In the early days of the celebration, the circus drew large crowds, as illustrated by this 1916 photograph. Here, attendees are watching the performance of a unicyclist. The photograph, taken at the corner of Grove Street and Magnolia Avenue, shows the Grandview Hotel and the Sunbeam Grocery. (Courtesy of the Lake County Historical Society and Museum.)

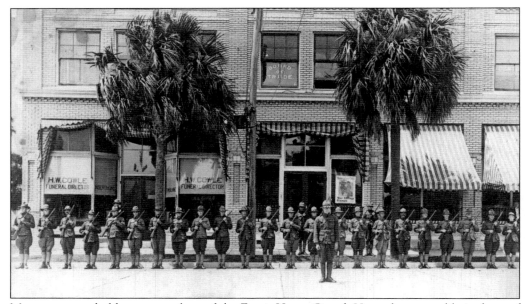

Men, young and old, were members of the Eustis Home Guard. Here, they assemble in front of H.W. Cowle Funeral Home and the Eustis Board of Trade before the 1918 Washington's Birthday Parade. A poster for war savings stamps is displayed in the window of the Eustis Board of Trade. (Courtesy of the Lake County Historical Society and Museum.)

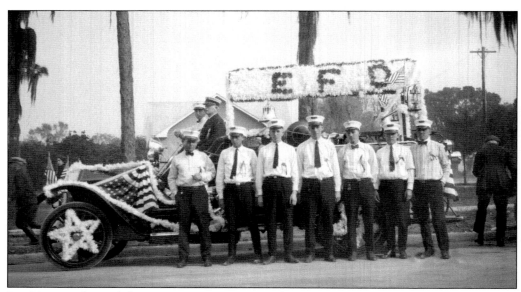

In 1924, members of the Eustis Fire Department show off their artistic talents on their tissue paper–decorated truck. Dressed in their best uniforms, members get ready to ride. The department still participates in the parade, each year exhibiting its latest equipment.

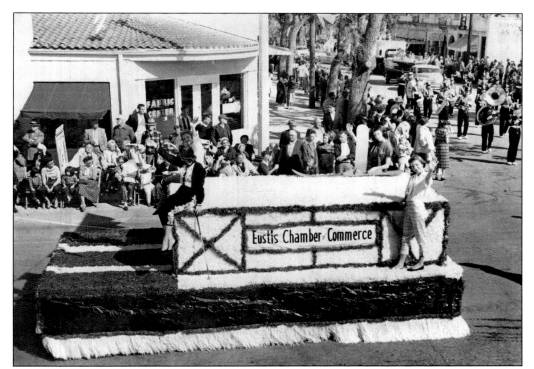

Turning the corner of Grove Street and Magnolia Avenue, the chamber of commerce's c. 1958 float is shown with riders Vivian Thompson, Judy Wood, Bonnie Morgan, and Janet Ferran. Waterman Hospital is to the right, and looking north on Grove are the Gas Company, Southern Printing, and Mathers Furniture Store.

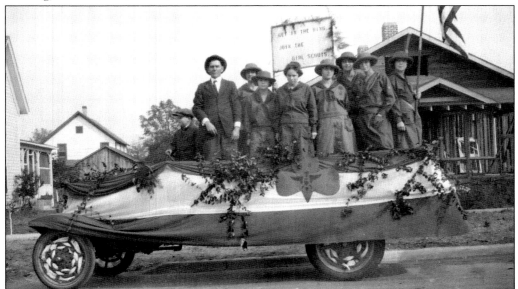

This 1926 float for the Girl Scouts encourages girls to "Get in the ring join the Girl Scouts." Eustis has always been very active in the support of both boys' and girls' scouting organizations. (Courtesy of Porter's.)

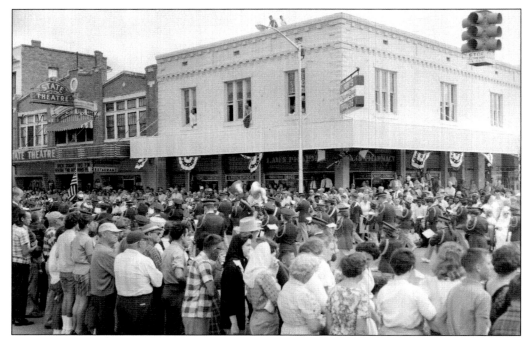

A large crowd is gathered on the corner of Magnolia Avenue and Bay Street in the 1950s to view the parade. Hand-made and professionally decorated floats attract visitors from surrounding counties as well as Eustis residents. Other crowd pleasers in the parade include state and local dignitaries, beauty queens, state and local bands, horse groups, and antique automobiles.

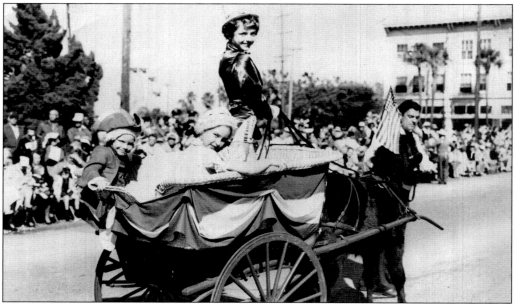

Donna Houston Porter is riding in a hand-carved cart pulled by donkey in this photograph from the late 1950s. The Arborio Building on the corner of Bay Street and Magnolia Avenue, occupied by the B.E. Thompson Furniture Company, is at the top right. Children dressed as George and Martha Washington ride in the rear of the cart.

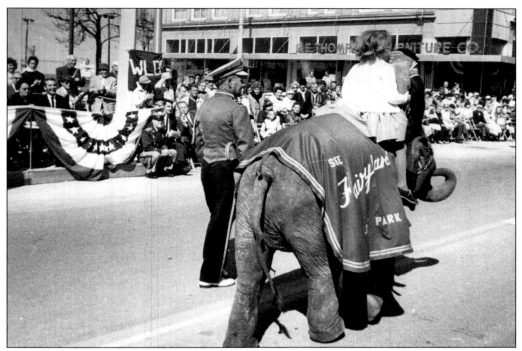

A baby elephant marches down Bay Street in the parade. The judge's stand is seen at left. Local radio station WLBE is broadcasting a live commentary of the parade.

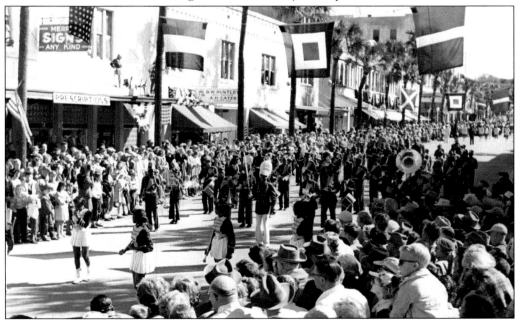

The award-winning Eustis Vocational High School band marches in the parade in the 1950s. The devoted support of donations and fundraising events from the EVHS community of businesses and parents contributes to the success of this band. (Courtesy of the Lake County Historical Society and Museum.)

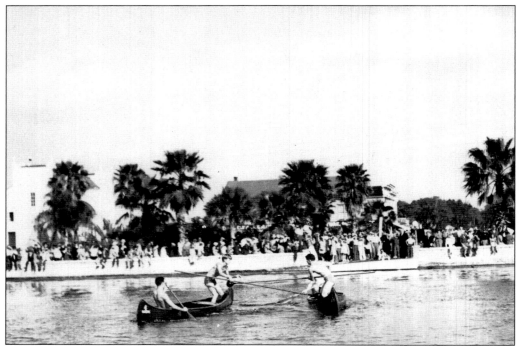

One of the more unique contests held during the celebration was "Tilting." Boys in canoes attempt to knock each other out of their canoes. And a good time was had by all. (Courtesy of the Lake County Historical Society and Museum.)

February 22 is a red-letter day for the local and visiting boat fleets. All kinds of boat races and water carnival sports are planned to make Washington's Birthday the one big boating festival of the year. It is largely attended, and combined with activities during the day, the celebration usually winds up with dances, music, and other entertainment held in various other parts of the city.

Five

HISTORIC
CHURCHES AND SCHOOLS

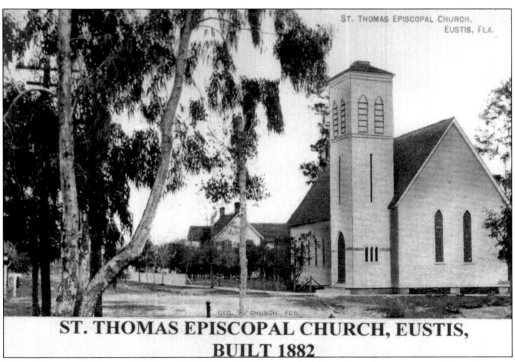

ST. THOMAS EPISCOPAL CHURCH,
EUSTIS, FLA.

GEO. W. CHURCH. PUB.

ST. THOMAS EPISCOPAL CHURCH, EUSTIS, BUILT 1882

Saint Thomas Episcopal Church, built in 1882, was the first church constructed in the new town and the county. Originally, all worshippers gathered for services in Clifford's Hall, under the ministry of Dr. J.H. Potter. As more people settled here, individual congregations began to grow. The first Kindergarten opened in Wisdom Hall, located on Orange Avenue and Dewey Street, on October 6, 1906.

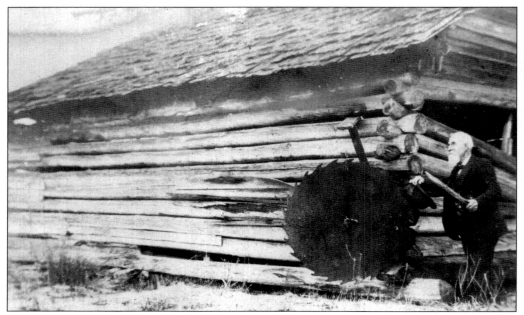

A very early log church, possibly located outside of town, used a large sawmill blade as a bell to call the members to meetings. By 1884, many sawmills were in operation to furnish the lumber needed for building the new town. One, operated by Stephen Walker and Guilford D. Clifford three miles from town surrounded by first-class timber, was reputed to be one of the most reliable.

This beautiful wooden one-room building, built in 1886, was the home of the First Methodist Church. Built at the corner of Citrus and Prescott Streets on land donated by the Prescott family, it had a pipe organ, a bell tower, and stained-glass windows. The church had no parsonage until one was purchased on Citrus and Salem Streets in 1897. (Courtesy of the Lake County Historical Society and Museum.)

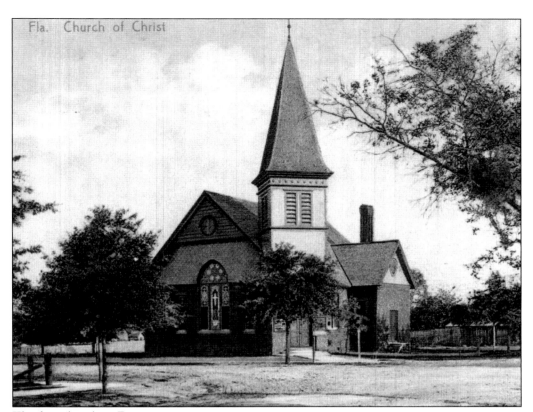

Fla. Church of Christ

The first church in Eustis was begun in 1891 as a large tent erected on Orange Avenue and Center Street. Gasoline lanterns lighted the tent, and chairs were borrowed from schools. After public opposition to the tent church, Edgar Ferran, Harvey Glass, and Dr. William Kimbrough Pendleton secured property, and construction was begun on a real church. Shown above is the redbrick, Classical-style Church of Christ with gables of cypress that was built in 1894. The church's interior featured a tin ceiling in Arabic design, paneling made from apple crates, stained glass from Europe, and memorial windows. Dr. Pendleton, the first pastor of the church, was one of the most influential of the pre–Civil War preachers and pioneer leaders. He was formerly the president of Bethany College in West Virginia.

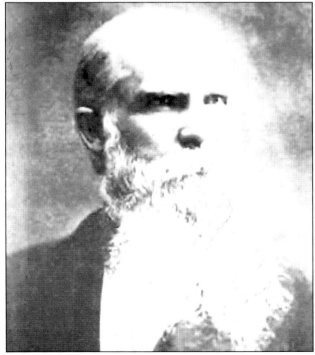

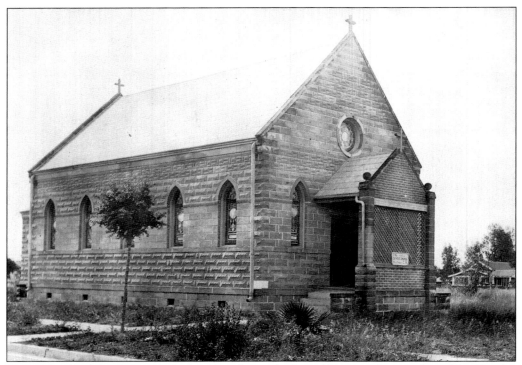

Saint Mary's of the Lakes Catholic Church was built in 1911 on a lot purchased by Charles Magargee and J.J. Ott. Originally, the congregation made the 40-mile trek to Sanford to worship. In 1911, the Catholic community had grown and was established as a mission of All Souls Church in Sanford. The first church held 50 parishioners and was dedicated on January 8, 1912, by Bishop Kenny. (Courtesy of the Lake County Historical Society and Museum.)

Retired Iowa minister Dr. James Hare Potter arrived in Eustis in 1883 to visit friends. As his poor health improved, he began holding religious services in Clifford's Hall. After preaching regular services for months, he organized a Presbyterian church and was instrumental in the planning and building of a church, dedicated debt-free in January 1885. (Courtesy of the Lake County Historical Society and Museum.)

In 1884, the small congregation of Eustis Presbyterian decided to build a church. Mr. Pendry donated the land, and members provided the $3,750 needed to build. The congregation of 112 members outgrew the building by 1912. A large stone building was erected on the same site. The building pictured was turned onto the back of the lot and rearranged for the Sunday school. It later became a recreation building. (Courtesy of the Lake County Historical Society and Museum.)

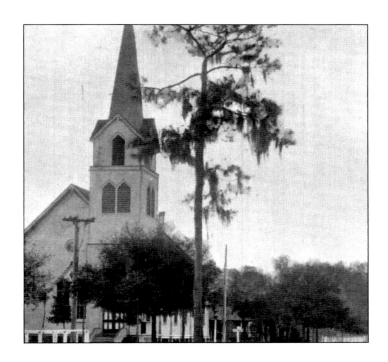

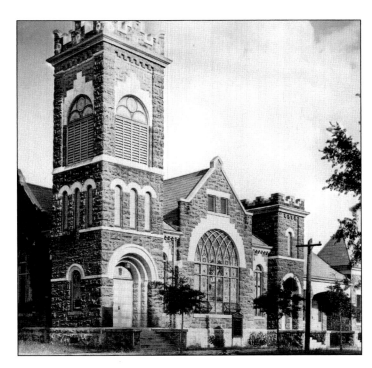

This imposing Romanesque structure of frame construction faced by concrete stucco–styled masonry, built by W.B. Scott, was completed in 1912 at a cost of $25,000, replacing the older frame Presbyterian church. Dedicated debt-free on April 5, 1914, the auditorium seated nearly 600 people. The story goes that when the church ran out of materials, Ray Ferran, who was building a home of the same masonry, donated the materials he had on hand to complete the church. (Courtesy of the Lake County Historical Society and Museum.)

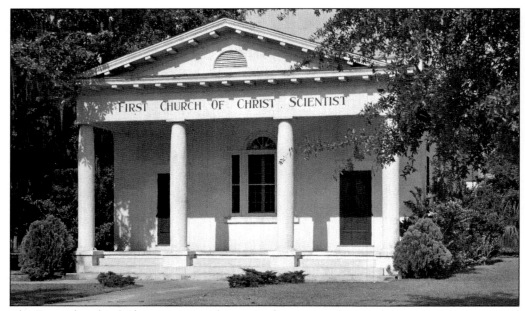

The First Church of Christ, Scientist began in the winter of 1911 when a small group started holding meetings in Wisdom Hall. The church was chartered in 1918, and in 1922, the present Classical Revival–style building was erected on the corner of Grove Street and Lemon Avenue. The society became First Church of Christ, Scientist in 1928. (Courtesy of the Lake County Historical Society and Museum.)

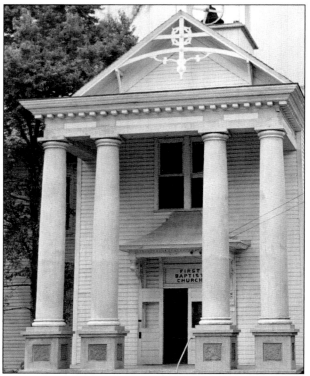

The first building occupied by the First Baptist Church began its life as the Eustis School, which opened on February 1, 1886, with Prof. W.R. Vaughn as principal. However, that building was destroyed by fire. This lovely Greek Revival–style building, constructed in 1926, replaced the older one but, sadly, it too was lost to fire in the 1950s. (Courtesy of the Lake County Historical Society and Museum.)

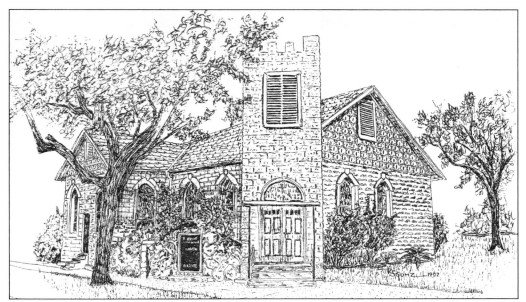

The first African American church in Eustis was a brush arbor on Ward Avenue. Rev. Charles H. Holly was pastor from 1884 to 1896. In 1914, Gethsemane, a gray stone T-shaped church, was constructed on the corner of Woodward Avenue and Bay Street. The sanctuary used today is a later building.

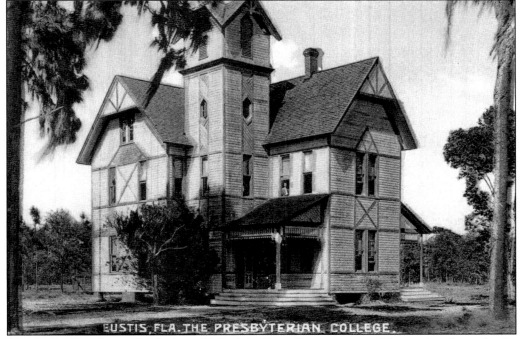

Ohio native Prof. Bryon. F. Marsh established the Eustis Seminary, one of the area's earliest schools, in 1886. No funding was available for private schools, so it was built as a public subscription project. All grades were taught at the school, and the courses of study were divided into "classical, scientific, and academic." The Big Freeze eventually led to the closure of the school.

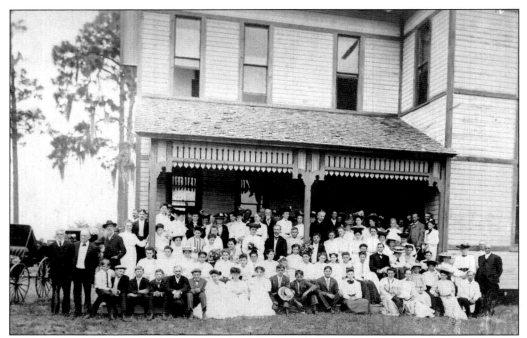

Students are shown at a Presbyterian Day Party on October 4, 1905, at B.F. Marsh Private School (Eusits Seminary). The building was at the corner of Washington and Fahnstock Avenues. It housed classrooms and administrative offices and was later used as a private home.

Pictured is the 1892 graduating class of the Eustis seminary. From left to right are (first row) Lucy Ferran, unidentified, and Ella Medenhall; (second row) Dr. Benjamin Marsh, the founder of the school, and two unidentified. (Courtesy of the Lake County Historical Society and Museum.)

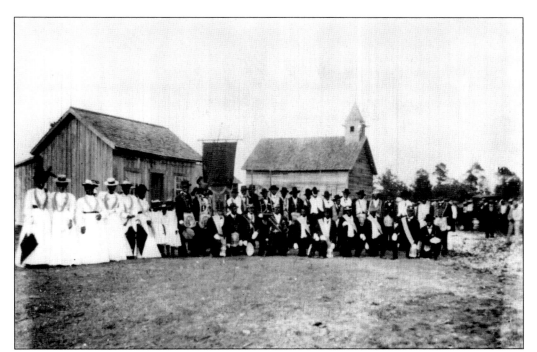

Religion and education were a strong part of African Americans' daily life. These rare early photographs of a church gathering and a wooden school building, believed to be Little Egypt, depict some early activities of the communities of Egypt and Jerusalem in Eustis. In 1887, the *Orange County Gazetteer* listed a "colored school number 85" in the northeast part of town called Egypt, which was where black families settled. The school was located at Clifford and Exeter Streets. In the early 1900s, Lula Sharpe and Anna Sharpe were among the first teachers in Egypt. The school closed in 1968. (Courtesy of the Lake County Historical Society and Museum.)

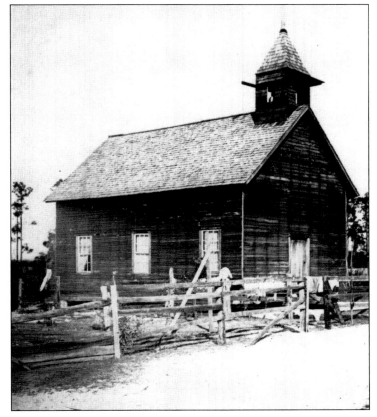

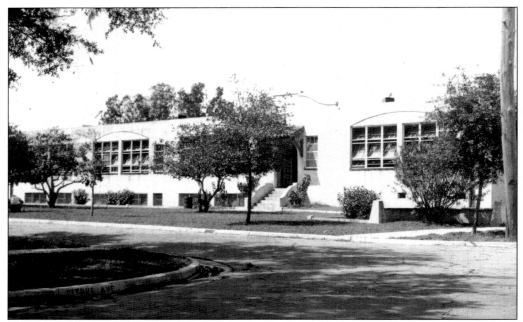

The Mission-style Eustis Elementary School, located at 714 East Citrus Avenue, was built in 1924. The architectural style includes a barrel tile roof, arched entryways, and columns that form a covered walkway. At one time, the school housed all 12 grades. It is still used today for teaching kindergarten and the first through fifth grades. (Courtesy of the Lake County Historical Society and Museum.)

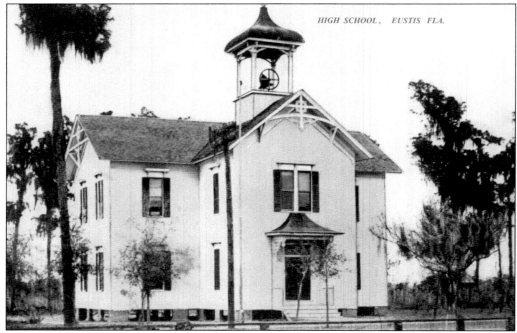

The first Eustis High School was constructed in the Florida Gothic style and built in 1891. (Courtesy of Porter's.)

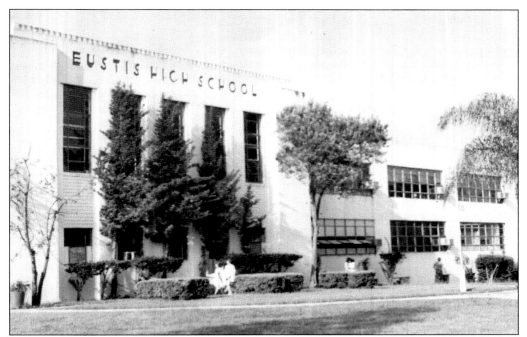

This photograph of the Eustis High School on Washington Avenue shows the Mission-style building that was constructed in 1941. Both authors attended this school and graduated from there with the class of 1959. (Courtesy of the Lake County Historical Society and Museum.)

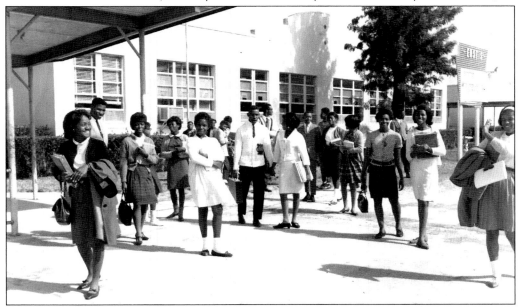

Education for African Americans began in Eustis in 1887 when school was held in churches. In 1926, Curtwright Vocational School, named for its principal A.C. Curtwright, opened. With James S. Pinkney as principal, the name was changed to Eustis Vocational High School in 1941. Since 1999, this section of the school is known as the Curtwright Campus and houses the ninth grade annex to Eustis High School.

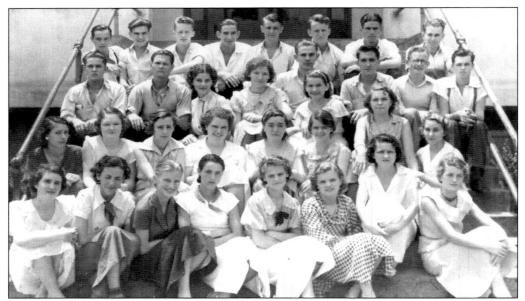

Here is Eustis High School's graduating class of 1934. Pictured from left to right are: (first row) Sara Bailes, Isabelle Mantey, Jacquezine Bailes, unidentified, Jeanne Choate, unidentified, Imogene Harper, and Bessie Buchanan; (second row) ? Barrett, Jessie Getford, Bessie Bray, Madge Barnes, Eleanor Nearpass, Eleanor ?, two unidentified, and ? Harper; (third row) Clarence LaRoe, Eddie Smoak, June Crooks, Ann Skinner, Martha Nerd, Buster Williams, Bernard Boyce, Edwin Fields, and Guy "Smiley" Merry; (fourth row) Julian Merry, Bill Cathrae, James ?, Paul Hudson, Barfield Grantham, Richard Jones, Everette Harris, and Fletcher Sturdivant. (Courtesy of Buster Williams.)

Shown here in a reunion photograph of the Class of 1933 are, from left to right (first row, seated on floor) Jeanne Choate Ferran, Laurabelle Ferran, Nell Kennedy Harris, and Clarence LaRoe; (second row, seated) Don Haselton, Rev. Fayette Hall, Priscilla Polk, Florance Hopson Gause, Buster Williams, Ruth Choate McGinn, Jackie Bailes Opps, and John Boyle; (back row) Parks Williams, Ann Jackson Hannah (seated), Bobby Banks, Don Porter, and Ed Squires.

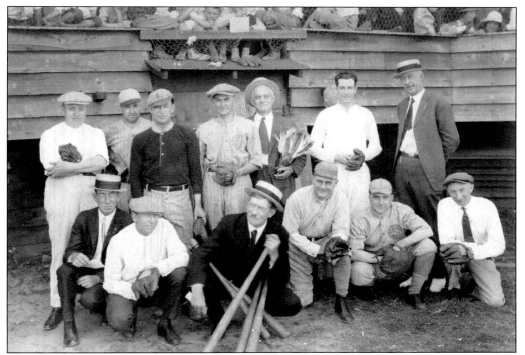

Members of the Eustis Baseball Club, a semiprofessional team, seen here on May 2, 1924, are, from left to right: (first row) Clarence Williams, Carl Ferran, I.N. Kennedy, George Pierce, John Nichols, and Harry Hannah; (second row) J. Mattlock, Ansil Miller, J. Taylor, M.H. Moore, Ray Ferran, Harry Ferran, and George Wheeler.

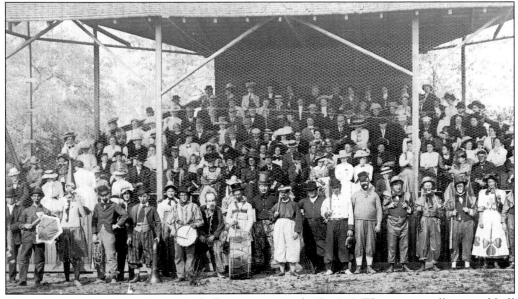

This crowd is enjoying a day at the ball game on March 17, 1910. The municipally owned ball field was located at the corner of Starbird Street (Now Kurt Street) and Chesley Avenue, next to the airfield. (Courtesy of the Lake County Historical Society and Museum.)

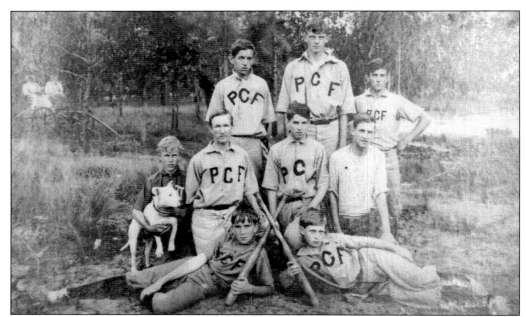

These two photographs are of the Presbyterian College baseball team. Among the players were Stin Haselton and Carl Ferran. Baseball played a major role in sports life in Eustis; there was even a minor league team, the "Eustis Baltimore Orioles." The Baltimore Orioles, six-time winners of the International League championship, arrived March 4, 1925, to begin their spring training in Eustis. More than 50 fans and a number of automobiles were on hand to greet the team when its train arrived. The players were transported to their accommodations at the Fountain Inn Hotel. The team and its manager Jack Dunn were honored at an informal public reception at the Fountain Inn in the evening. (Below, courtesy of the Lake County Historical Society and Museum.)

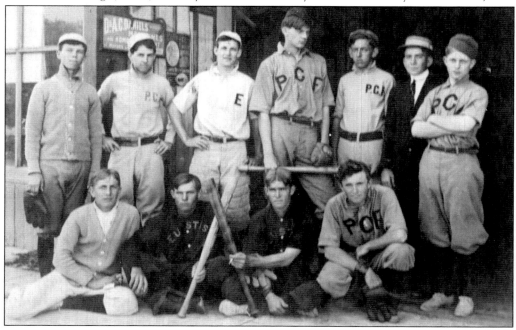

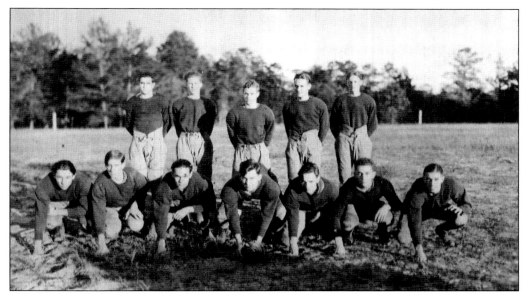

Here is the 1930 Eustis High School football team. Pictured are, from left to right, (first row) Harry Feigin, Jim Kinser, Festus Morgan, Murray Thomas, Hal Loshbough, Hubert Miller, and Joe Eckholdt; (second row) Richard Bolton, Harry Hannah, Kenneth Glass, Roy Morgan, and Tom Hannah.

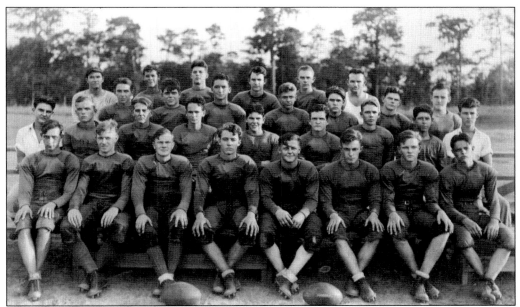

Here is the 1932 Eustis High School football team. Team members include, from left to right, (first row) Parks Williams, Alan McDonough, Tom Skiff, Harry Thomas, Dwight Bray, Dick Lum, Byron Dean, and Julius Odum; (second row) Bill Cathrae Gene Isted, Donald Porter, Mack Morgan, Bill Isted, Roger Horne, Bill Quayle, Arthur Smock, and Ed Squire; (third row) Paul Hudson, Hubert Earnest, Frank Skinner, Barfield Grantham, Clarence LaRoe, Jim Mulholland, and Richard Jones; (fourth row) coach Memory Martin, Raymond Slaven, Carl Story, Murray Thomas, Buster Williams, and coach Frank Banning.

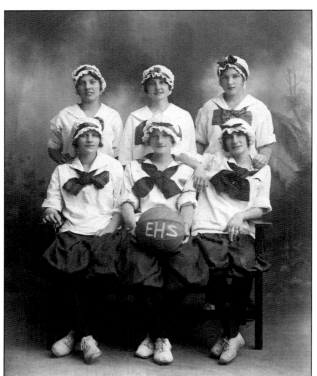

This undated photograph shows the Eustis High School girls' basketball team members in their uniforms and fancy caps. (Courtesy of Porter's.)

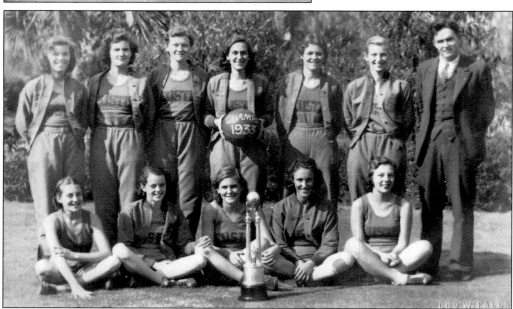

The men and boys of the town were not the only ones who excelled at sports, as evidenced by this photograph of the 1933 champion girls' basketball team. Team members included, from left to right, (first row) Loretta Ludlam, Libby Hancock, Ollie Mae Paterson, Mary Lib Lumm, and Virgina Williams; (second row) Chesley Prielou, Sara Bailes, Sara Hethcox, Ruth Choate, Pat Patterson, Jacqualine Bailes, and coach Memory Martin. (Courtesy of Jim Brady.)

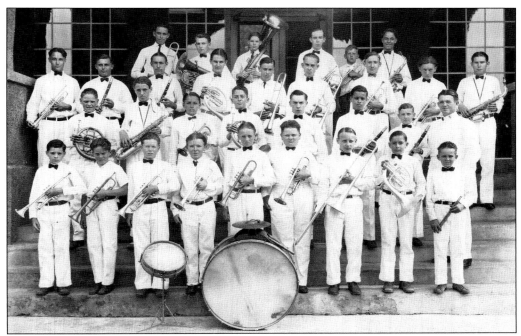

The award-winning Eustis Boys' Band was made up of elementary and high school students. In the 1920s and 1930s, the Eustis Rotary Club organized and financially supported the band. The director, Capt. Jimmy O'Neal, and the band of 50 members performed weekly concerts locally and around the state. O'Neal later became the director for the Eustis High School band. In 1928, the band won first place in the first state high school competition. (Above, courtesy of the Lake County Historical Society and Museum.)

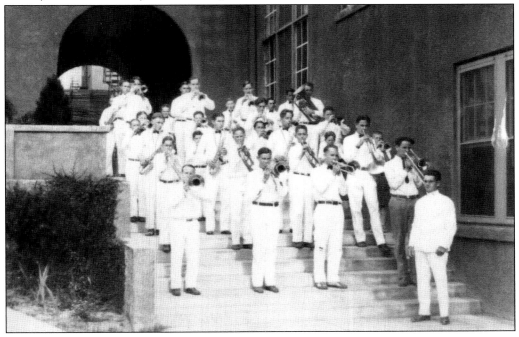

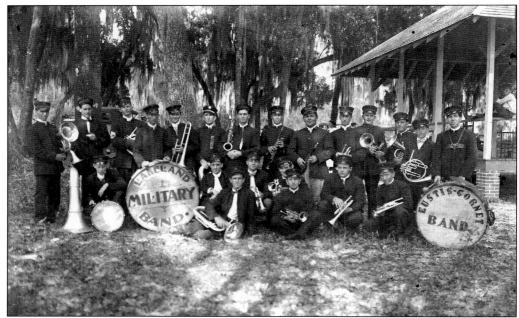

Pictured here are the Eustis Cornet Band and Lakeland Military Band. Combined musical groups, like these two bands, traveled around Florida during the winter months playing at events. Many of the band members were visitors from the north who played in professional bands, such as with Sousa, for the rest of the year. (Courtesy of Porter's.)

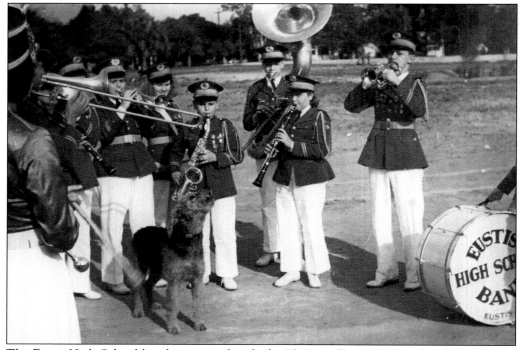

The Eustis High School band is pictured with the "Singing Dog" in an undated photograph. Louise Burell is on cornet. Others are unidentified.

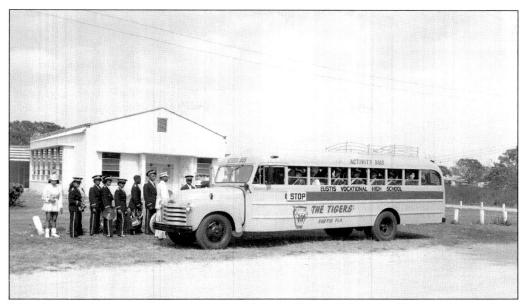

This photograph represents a great example of dedication and ingenuity. Supported by teachers, parents, and businesses, the students of Curtwright Vocational School were undaunted after being refused county funding for a school and band activities bus. They set out to raise the necessary funds themselves by selling baked goods, including sweet potato pies, to purchase the big yellow bus named "Tiger." (Courtesy of the Lake County Historical Society and Museum.)

This 1950 photograph shows the young ladies of the Socialite Services Club. From left to right are Nancy Harris, Azalee Mackey, Sarah Williams, Susie Roberson, Ozzie Bell Terell, Margaret Ware, Alvedia Sewell, Josephine Harris, and Cheley Williams. Most of the girls became leaders of their community and raised families in the area.

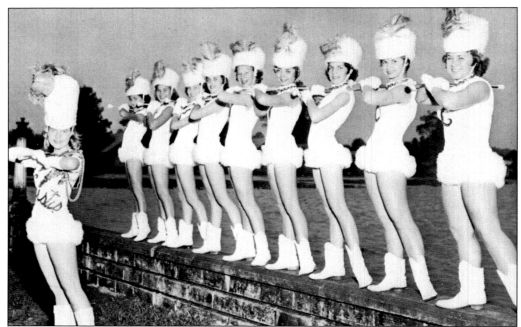

This 1958 photograph was taken on the sea wall of Ferran Park of members of the Eustis High School Majorette Corps, led by head majorette Barbara Bruce. Those pictured are, from left to right, Beth Davis, Scarlette Ellis, Patsy Ramer, Connie Love, Sandra Mabry, Sonja Haselton, Dorothy Campbell, Janice Hill, and Joretta Dailey.

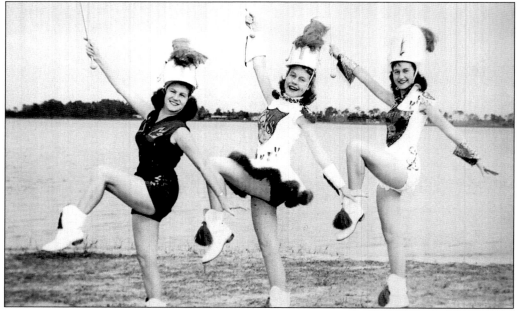

Deloris Carter, instructor of award winning auxiliary Eustis High School band flag, baton, and rifle units and English teacher, poses with students Barbara and Bette Bruce. Carter's summer baton camp at Lake Joanna attracted applicants from as far away as Nassau, Paris, and Belgium. Majorettes from across the state participated yearly in the Washington's Birthday Celebration.

Six

THE RISE OF
BUSINESS AND INDUSTRY

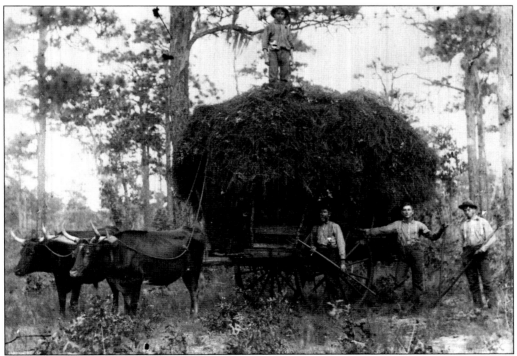

The *Gazetteer* reported in 1887 that Eustis had a thriving industrial area. The business sector included a bank, four hotels, two telegraph and railway offices, many specialty and general stores, a cold storage and icehouse, and three churches. A new public school was being built, and there were no saloons. One unique business involved moss gathering for use in furniture and mattresses. It was the foam rubber of the day. (Courtesy of the Lake County Historical Society and Museum.)

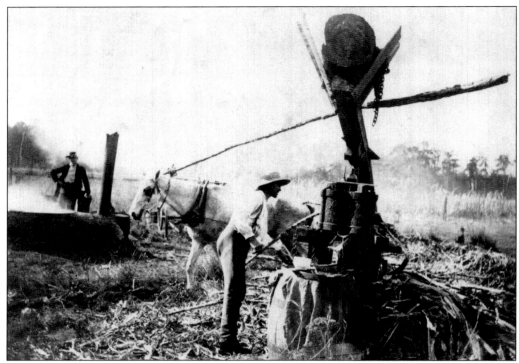

This horse-drawn sugarcane mill is using what appears to be a flattop mill, which was produced until 1904. Once the cane is stripped, topped, and cut, it was then hauled to a mill, ready to be ground. The juice moved through a heating process and into a "teache" to become syrup. After cooling, sugar crystals formed, and the raw sugar was barreled and put in the curing house.

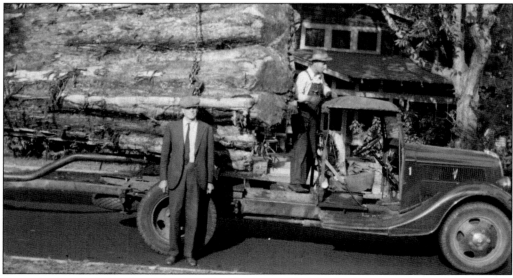

Extensive longleaf pine forests surrounding Eustis provided the lumber needed to build the homes and businesses of the new town. Logging trucks, like this one, transported the logs to the local sawmills like Walker & Company and to the Eustis Planing Mill. Edward Hore (pictured here) and his crew of 15 men did planing, scroll sawing, woodturning, and furniture making.

Shown is the Southern Turpentine Plant. Abundant longleaf pine forests provided the raw material for the production of turpentine, a fluid obtained by the distillation of resin obtained from the trees. Used for thinning oil-based paints, for producing varnishes, and as a raw material for the chemical industry, turpentine became the second largest industry in Florida by the late 19th and early 20th centuries. Many African Americans worked and lived in settlements called camps at the stills. Conditions were harsh, and workers were paid as little as 10¢ per hour or were given company tickets that they used to buy supplies from the company store. Other industries, such as sawmills, blacksmiths, and barrel makers, were required to support the production of turpentine. By the 1970s, turpentine was no longer a major industry in Florida.

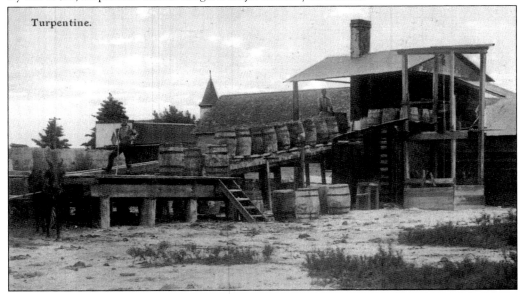

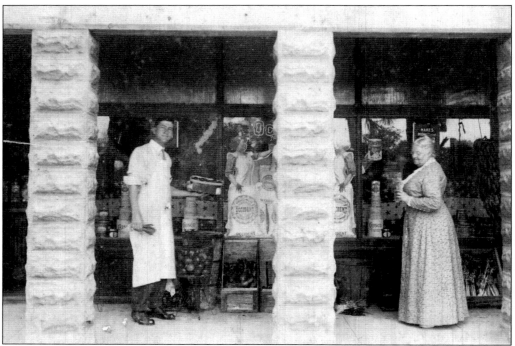

Stratford Story and Irene Vogt are pictured here in front of the Sun Beam Grocery on the corner of Grove Street and Magnolia Avenue. Vogt was the wife of Benjamin H. Vogt, who founded the first newspaper in Eustis, the *Semi-Tropical*, in 1881.

This buggy is in front of the Arthur G. Smith grocery store on Bay Street in 1910. Smith was one of several food store merchants in the downtown area. He advertised having "everything good to eat," and his telephone number was simply "1." (Courtesy of the Lake County Historical Society and Museum.)

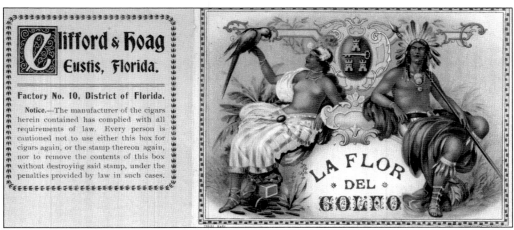

A Clifford and Hoag Cigar Label was discovered in the Clifford House among other items, including a wooden cigar box with the labels attached and the rubber stamp for seal. Also in the Clifford Collection are maps, photographs, and correspondence from Cuba. During a time when people could freely trade with the island, Clifford, an entrepreneur, was assumed to have imported, packaged, and retailed the cigars in his store.

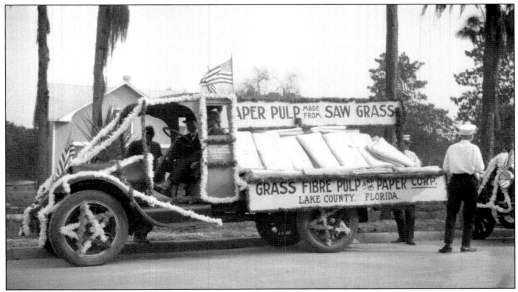

The Grass Fibre Pulp and Paper Corporation's Washington's Birthday float advertises "Paper pulp from saw grass." The company harvested the saw grass from Lake Harris. A large sedge plant thrives on water and is found at river and lake banks in Florida; it is considered one of the oldest plant species. It has tough, edged leaves that can weather year-round flooded conditions of the harsher swamps.

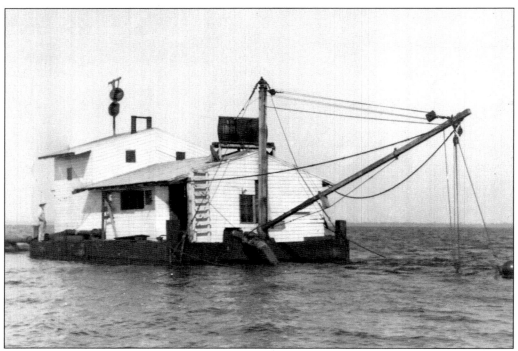

These views of two floating barges loaded with dredge equipment were visible from the upper-northwest window of the Clifford-Taylor home in the early 1920s. As more boats were mooring along the lakefront, dredges were busy deepening the lake shorelines. The sand removed from the lake was shipped on railroad cars to concrete plants and used locally. Eustis was blessed with an astounding lakefront. As sails flurried, sightseers stared, and newcomers arrived from the intracoastal waterway. (Courtesy of the Lake County Historical Society and Museum.)

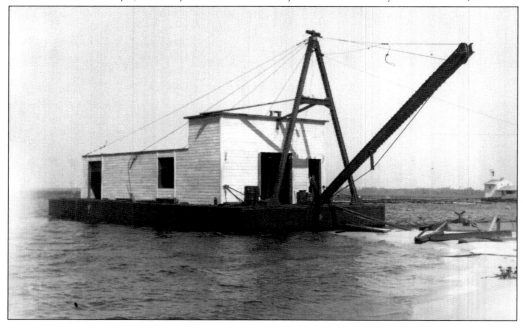

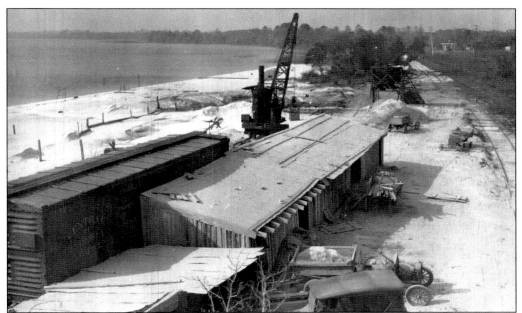

The Wylie Sand Company was one of the busiest businesses in north Eustis. Wylie was located on the northeast shore of Lake Eustis, which is known for its pure white, fine quality sand. It was not unusual to see train cars lined along the tracks all through town waiting their turn to load. Sand was shipped to Corning Glass Works in New York for use in their dinnerware. Florida concrete plants ordered carloads of the sand, because it gave the concrete the texture desired when dried in their forms. There were also everyday, local uses of the sand, such as backfill, driveways, and so on. (Courtesy of the Lake County Historical Society and Museum.)

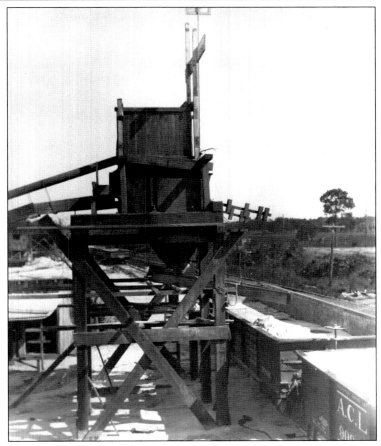

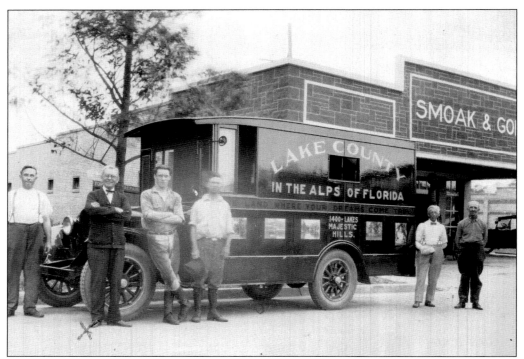

Pictured outside their Goodyear tire dealership are Conner Smoak (left) and William A. Goin (second from left). The others are not identified. This store was where Ace Hardware stands now, on the corner of Orange Avenue and Eustis Street. (Courtesy of Dorothea Smoak Rice.)

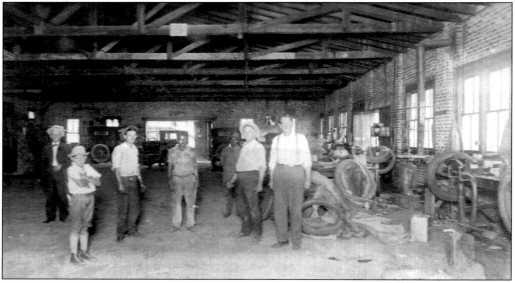

Here is a c. 1925–1926 interior view of the Smoak & Goin tire repair shop. The shop, conveniently located on Orange Avenue, between Eustis and Bay Streets, was one block south of the Dixie Highway, which ran from Chicago to Miami. Lake County was among 24 Florida counties represented at a historic road-building project meeting held in Orlando on June 11, 1915. About 350 delegates were present at the meeting, including one from Eustis.

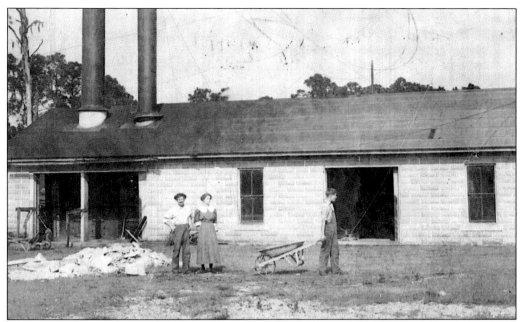

The Eustis Water & Power Plant, located at the corner of Lemon and Morin Streets, is shown here in 1911–1912. Pictured here are Mr. and Mrs. John Short and their son Johnny (with the wheelbarrow). The elder Short helped build the power plant. Tragedy struck the family when Johnny was killed during a storm when lightning struck the plant while he was near a transformer inside. (Courtesy of Bill Short.)

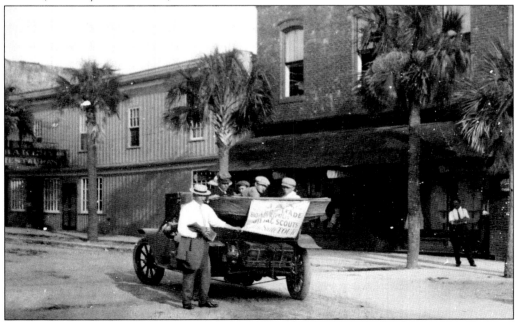

Local businessman Harry Ferran prepares to leave on a road trip from Eustis to Sarasota to promote tourism and the community of Eustis. The Board of Trade advertised on the automobile was the beginning of the Eustis Chamber of Commerce.

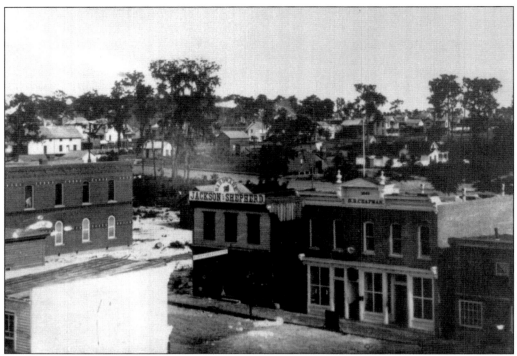

Pictured in this 1904 photograph of the corner of Magnolia Avenue and Eustis Street are the Jackson Sheppard Hardware Store on the left and the S.S. Chapman store on the right. George Church Jewelers is on the far right. The building on the southeast corner across the street is a drug store. (Courtesy of the Lake County Historical Society and Museum.)

Thomas C. Keys came to Eustis from Ohio in failing health. On seeing the potential for business success and regaining his health, he began Keys Furniture. After he purchased all of the stock of furniture and burial cases from C.T. Smith, he was the only furniture dealer in town. In 1895, he left and went to work for the Water Fountain Pen Company. After retirement, he returned to Eustis.

The Bay Street Pharmacy Soda Fountain served local citizens, teenagers, and tourists. In 1924, it became the Eustis Pharmacy and Post Office, with F.W. Hannum as proprietor. It then became Law Pharmacy and was the agent for Union Bus Line. Next, it became Bay Pharmacy with cosmetics, magazines, and a corner lunch counter. It suffered a tragic fire that destroyed the building. Today, the lot is a small park. (Courtesy of the Lake County Historical Society and Museum.)

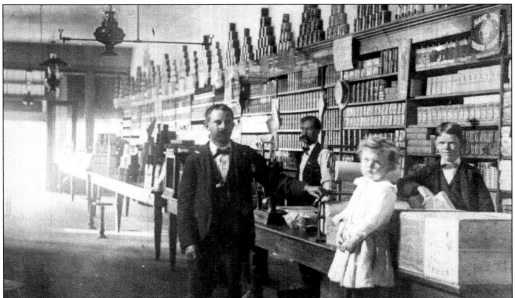

This interior view of the Ferran Store is undated but is believed to have been taken in the 1920s. The store advertised having the "largest and finest stock of goods, ladies dress goods, notions, carpets, and ladies' shoes ever exported for sale in this region." It became known as the store "with the squeaky floors." It closed in 1998 after 114 years of operation. (Courtesy of the Lake County Historical Society and Museum.)

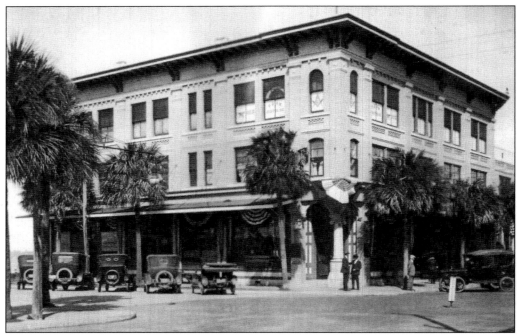

The Italianate-style Arborio Building, located at 108 North Bay Street, was built in 1881. Its distinctive architecture, with its heavy ornate wood brackets, divided bays, and dentil work, make it an imposing building. During its history, it has housed the State Bank, B.E. Thompson Furniture, a dentist office, and a hotel. As an example of adaptive reuse of historical property, the building is now used for shops and apartments.

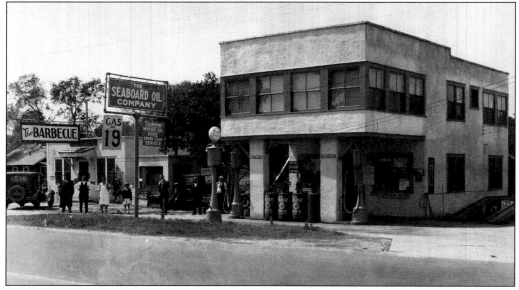

The Seaboard Oil Company gas station and the Barbecue served customers outside Eustis's south city limits on the Eustis–Mount Dora Dixie Highway. In 1925, hamburgers were a whopping 15¢, and gasoline was 19¢ a gallon. Fresh picked oranges from the tree between the buildings were sold at 15¢ a dozen.

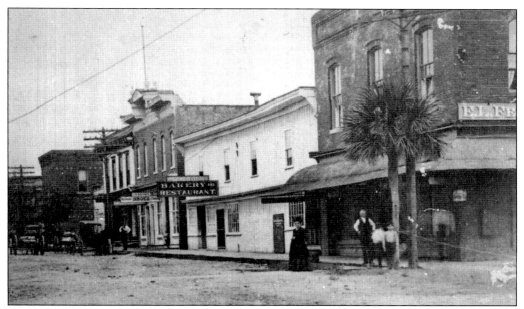

This 1895 photograph, taken on the corner of Bay Street and Magnolia Avenue, shows the stores in the first block of Magnolia Avenue, looking east from Bay Street. Edgar L. Ferran stands in front of his dry goods and clothing store. Schmidt's Bakery and Restaurant; C.H. Decker Dry Goods, Clothing, and Shoes; and William L. Church & Clock Repair complete the street scene. (Courtesy of the Lake County Historical Society and Museum.)

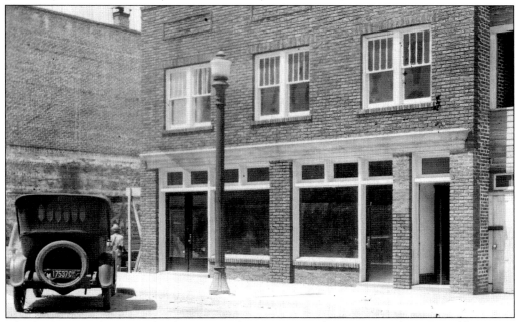

This building on the west side of Bay Street, between Magnolia Avenue and MacDonald Avenue, was owned by J.H. Fessenden and Arthur M. Dewitt. They opened a hardware and furniture store and funeral parlor in this building in March 1884. (Courtesy of the Lake County Historical Society and Museum.)

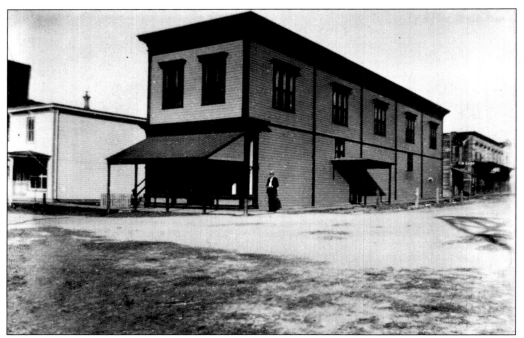

This two-story wooden building located on the east side of the unpaved Bay Street at the corner of Magnolia Avenue was one of the first buildings in Eustis. Later, this corner became the home of the Bay Pharmacy.

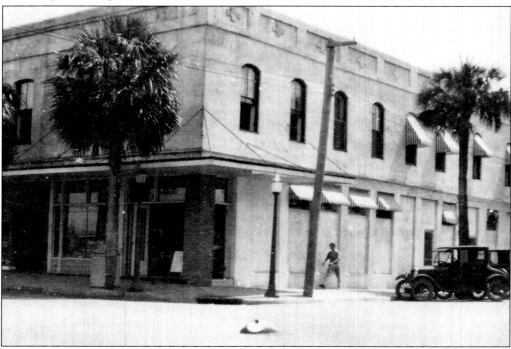

Here is a 1920s view of the southeast corner of Magnolia Avenue and Bay Street showing Magnolia Pharmacy. Notice the inground streetlight in the foreground

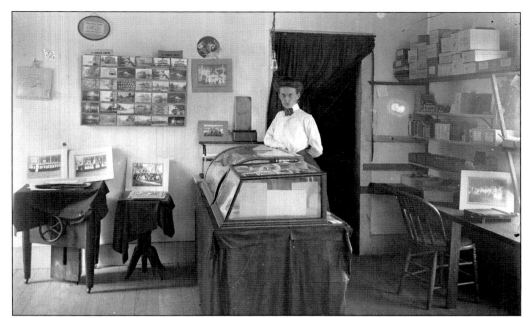

Louise Porter is shown here behind the counter of the family-owned Porter's Photo shop originally located on the second floor of a building on the corner of Bay and MacDonald over Huffman's Bike Store. Opened in 1909, five generations have been active in the shop. Still going strong today providing photographic finishing, camera equipment, and restoration of historic photographs, they enjoy a well-deserved reputation for preserving Eustis history in photographs.

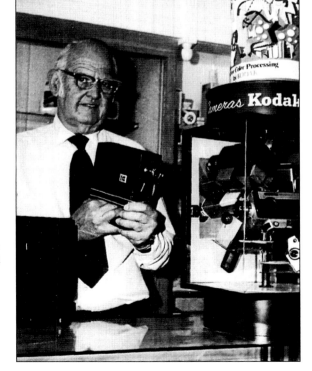

Shown here in a c. 1950 photograph is Donald Porter Sr. Porter's Photo shop has relocated to 120 Magnolia Avenue. Porter took photography at Eustis High School and since the teacher was not always there, he often taught the class since he had so much experience. At age 95, he is still semi-active in the business and has greatly helped the authors with his remembrances of names and places. (Courtesy Porter's.)

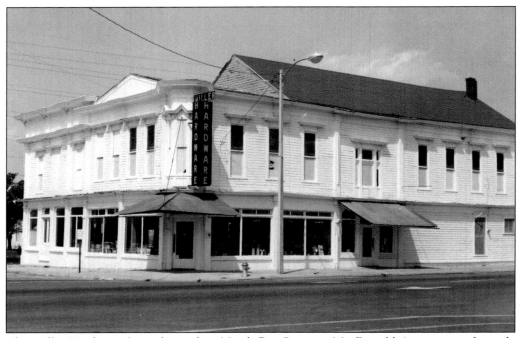

The Miller Hardware Store, located on North Bay Street at MacDonald Avenue, was formerly the Clifford Store built in 1881. In this photograph, the roofline has been altered from the very recognizable one that the building showcased during Clifford's time.

The Eustis Feed, Seed, and Supply Company, built in 1928 by Victor Shanor, backed up to the railroad where bags of feed and supplies were unloaded. It overlooked the Basset Boat Works on the lakefront. Today, the building is operated as a restaurant named Crazy Gator's. As a part of the revitalization of Eustis, this is a good example of adaptive reuse of a historic property.

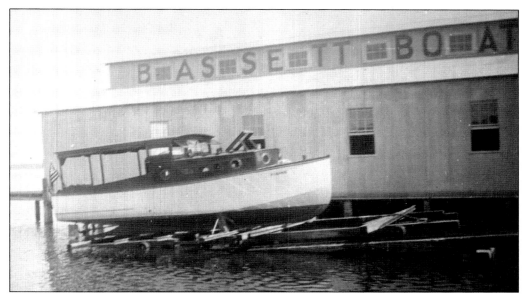

Fred Bassett Sr. owned Bassett Boat Works, shown in this 1927 photograph. Located on Gottsche Avenue, in the early 1900s, the company built boats of all sizes, ranging from a simple runabout to 55-foot-long houseboats. The family prided themselves on building boats that would last, using steam-bent oak frames, cypress sides, and mahogany decking. All the fittings were made of copper. They turned out glass-bottomed boats for Silver Springs, hydroplane race boats, and a 22-foot outboard cabin cruiser that was ahead of its time. Son Joe worked in the business with his father designing innovative craft. Fred Jr. got his first captain's license at age 14. The company built the *Dixie*, a 35-foot excursion boat that had cabins and windows that folded up or could be closed in rainy weather. (Below, courtesy of the Lake County Historical Society and Museum.)

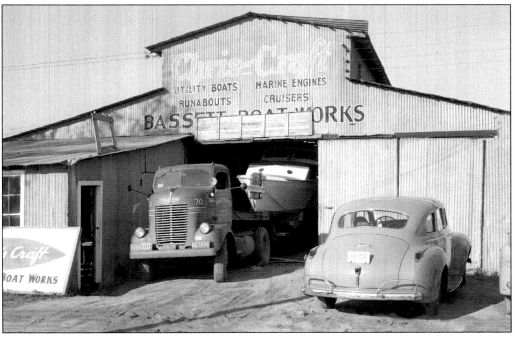

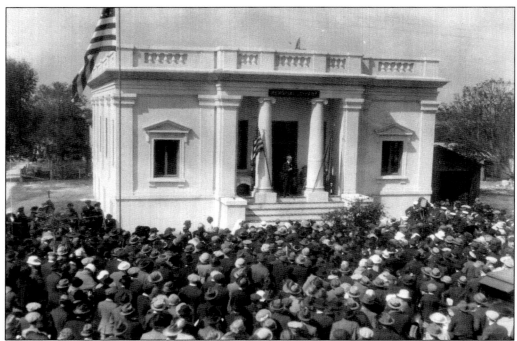

The Eustis Memorial Library, built in the newly popular Greek Revival style, was dedicated on May 1, 1923, by then-governor Cary H. Hardee, seen standing between the large columns. Almost the entire population attended. This building was joined, by way of an arch, to an identical one that was constructed to house city offices in 1927. In 1985, the library was relocated to a larger facility.

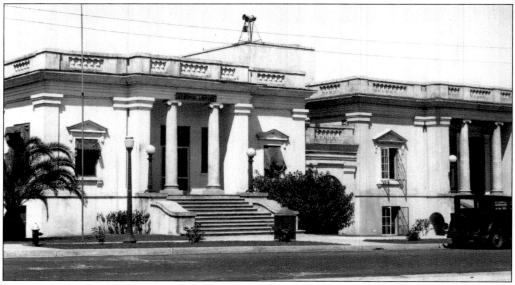

Shown in 1927 is the combined city hall and library on the corner of Orange Avenue and Grove Street. Originally, the building housed the fire and police departments and a municipal auditorium as well as administrative offices. Today, the city uses the entire building to house administrative offices.

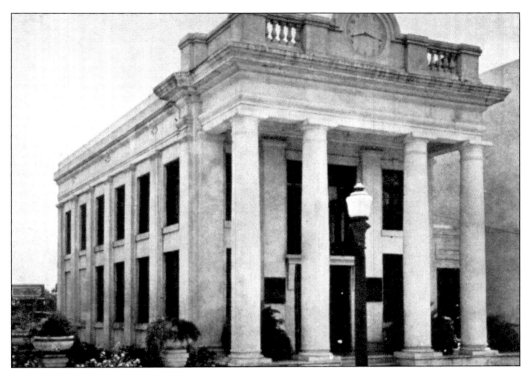

The Citizens Bank of Eustis at 23 Magnolia Avenue opened for business on December 18, 1912. George W. Holmes was president of the bank housed in this imposing structure. The first day's deposits were recorded as $1,957.26. The building was later used as a law office by Robert Stebbins.

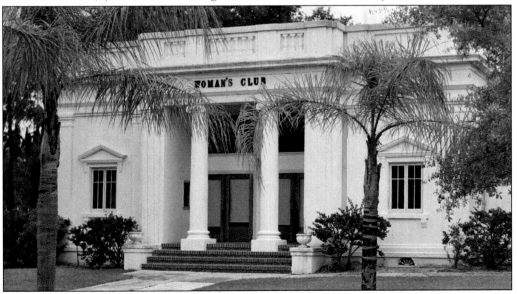

This grand, Classical Revival–style building, constructed in 1930, was home to the Women's Club of Eustis, organized in 1902. The members first met in the homes of members. Listed in the National Register of Historic Places in 1991, the building is owned by the City of Eustis and is undergoing restoration. (Courtesy of the Lake County Historical Society and Museum.)

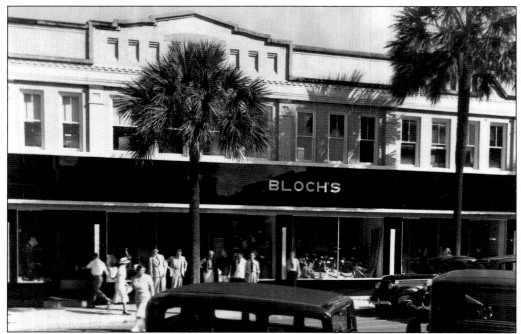

Bloch's Store, shown here, evolved into a series of shops in the 1950s that included Russell's Department Store. Today, the Peddlers Wagon Gifts Floral and Home Decor store and other shops occupy the space. (Courtesy of the Lake County Historical Society and Museum.)

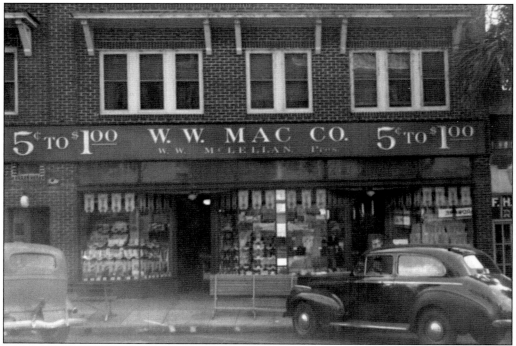

W.W. Mac Company was a variety department store, located on Magnolia Avenue in the block between Grove and Eustis Streets. They offered household items, notions, hardware, and clothing.

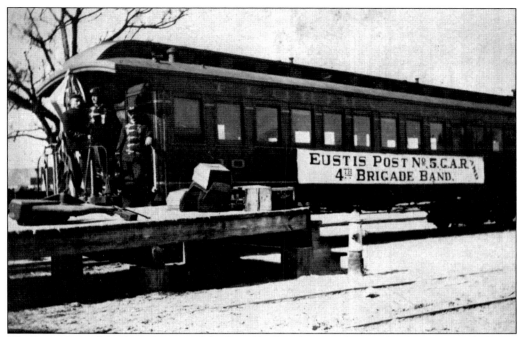

The Eustis Post of the Grand Army of the Republic listed 70 members under the command of G.H. Norton and met in Clifford's Hall. The organization was formed in 1884 by Civil War veterans and evolved into a political advocacy group with ties to the Republican Party. The last meeting of the post was held in 1923. (Courtesy of the Lake County Historical Society and Museum.)

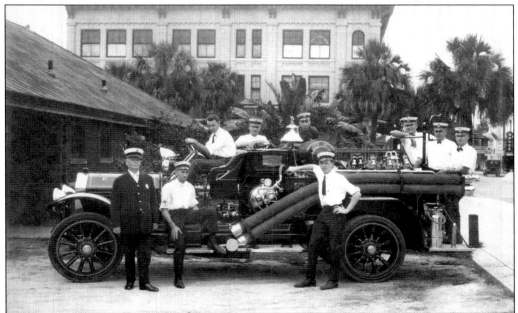

This new fire engine was purchased by the city in 1922. Among those pictured here with the truck are Stratford Story, Charlie Butler, Seward Church, and Bo Smith. The chief reportedly abandoned his bed, where he lay sick, to fight the Ocklawaha fire and subsequently died of pneumonia.

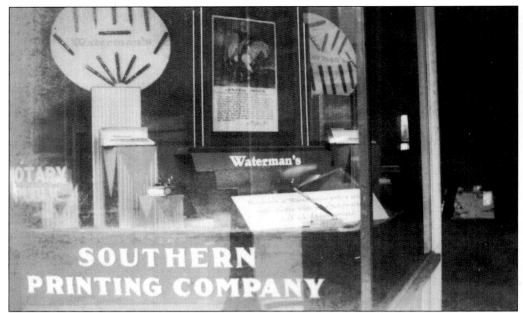

Southern Printing was located in the downtown area on Grove Street, just east of the Fountain Inn. The owner, Willis Haynes, operated from a small office area and provided most all the printing needs for the community, personal and business office supplies, and office equipment. In the photograph above of the window of his store is a display of Watermen Pens. He had a varied collection of the then-current writing utensils, as well as supplies for draftsmen and artists. The printing department produced quality printing for invitations, business cards, flyers, posters, and business logos. Southern Printing was one of the local businesses that took time and talent to produce printing products by hand. As machines and new technology overtook the industry, Southern Printing became another historic, friendly hometown business that did not survive. (Above, courtesy of the Lake County Historical Society and Museum.)

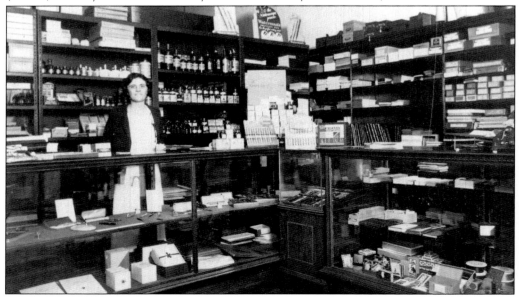

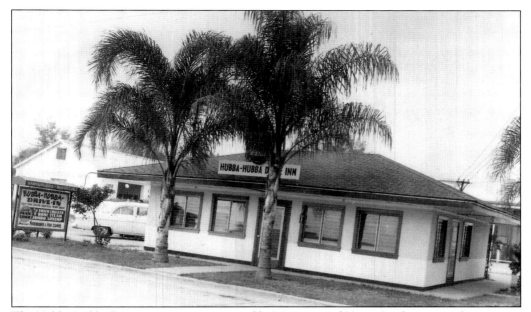

The Hubba Hubba Drive Inn restaurant, owned by Margaret and Henry Presherm, was the morning coffee spot where residents, businessmen, and police and sheriff officers, including Sheriff McCall, gathered. It was the local fast food restaurant in the 1950s.

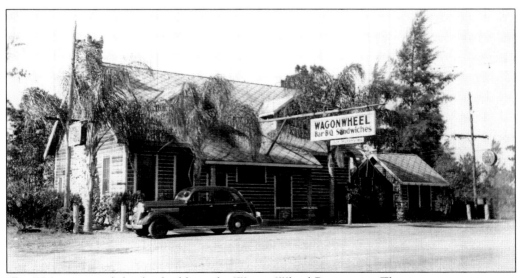

"Doc" Monn owned this log building, the Wagon Wheel Restaurant. This two-story restaurant with an upper loft, a large stone fireplace, and private booths, was across the street from a tourist court that had 34 cabins and space for trailers. The Wagon Wheel building became the Club Colonial, managed by Mr. and Mrs. Cerney. (Courtesy of the Kreigsman family and Porter's.)

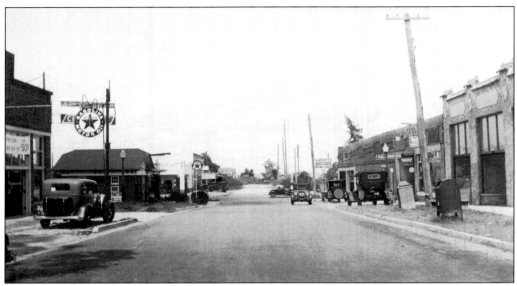

This c. 1930 photograph shows automotive related businesses on the section of Orange Avenue between Eustis and Bay Streets, looking west toward Lake Eustis. Visible are the Standard Oil station, Texaco station, a tire shop, and an auto repair. This road became part of US Highway 44, which runs from New Smyrna on Florida's east coast across the state to Crystal River on the west coast.

This 1940s streetscape, looking east at the corner of Eustis Street and Magnolia Avenue, shows the First State Bank, the Lake County Health Center, Vincent's Five and Dime, and the Western Auto Store on the left. On the right are the Palm Pharmacy, a laundry and dry cleaners, L.B. Moore Shoe Hospital, Porter's Photo, and W.W. Mac Company variety store.

Seven

THE NOTABLE PEOPLE AND PLACES OF EUSTIS

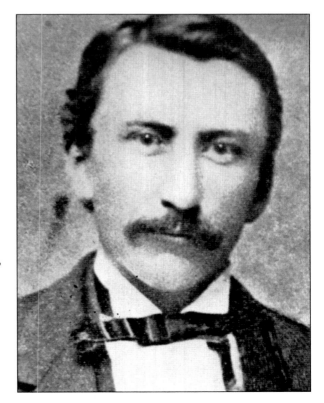

Guilford D. Clifford, an original settler, was very active in the development of the economic life of Eustis, serving on boards of churches, schools, and banks. He served on building committees for churches and was a member of city council and a school trustee. During hard times, he could be counted on to help those in need by extending credit for purchases in his store. (Courtesy of the Lake County Historical Society and Museum.)

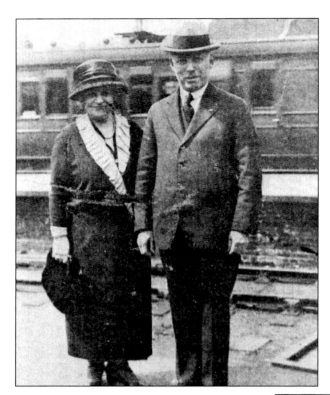

Frank D. Waterman and his wife, the former Margaret Austin McMillan, are shown in a photograph printed on silk fabric that was mailed from Japan to Mrs. Shaw around 1916. The Watermans, who owned the Fountain Inn Hotel, also lived on Park Avenue in New York City. (Courtesy of the Lake County Historical Society and Museum.)

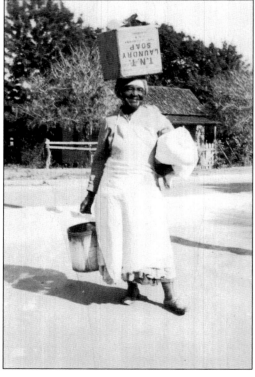

"Aunt Sally" Roe McCoy was often seen on the streets of Eustis balancing a huge bundle or basket on her head and pulling an express wagon. Born a slave in Cairo, Georgia, she was said to have been seven years old at the end of the Civil War. She led the George Washington parades each year wearing a patriotic costume; she was also a midwife in the town. (Courtesy of the Lake County Historical Society and Museum.)

This photograph of local music teacher Mina Fuller, taken in front of the A.G. Smith store in 1896, was made from a glass photographic plate. Glass plates were cheaper, and the transparency was far better than paper negatives. The photographer was A.G. Smith, an early pioneer who had an interest in nearly every pie in town. (Courtesy of the Lake County Historical Society and Museum.)

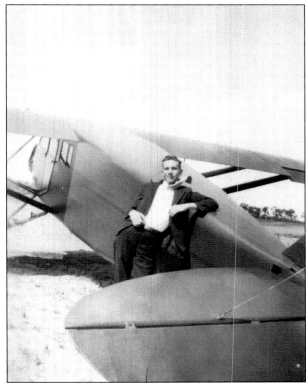

Elwin Moore poses in this 1933 photograph with his plane. Eustis boasted an airfield as early as 1923. By 1939, the F.D. Waterman Flying Field had two short clay runways that crisscrossed between Atwater and South Avenues, plus a longer one between Atwater and Chesley Avenues. The airfield hosted many kinds of entertainment, such as the tether and car races, air shows, and a motorcycle motor drome.

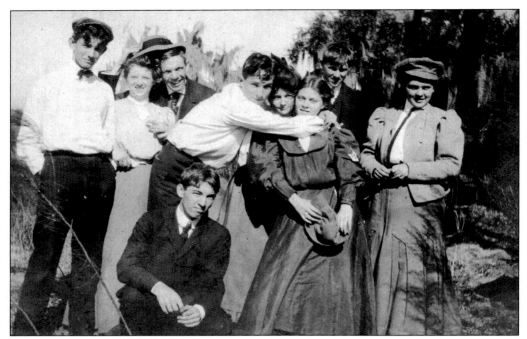

Young citizens of Eustis dressed in their best in 1906 are, from left to right, Forrest Gardner, Grace Peckham, James Taylor, Gordon Wright, Stinson Haselton, Gertrude Clifford, Leola Kipp, Milton Searole, and Helen Webb. (Courtesy of the Lake County Historical Society and Museum.)

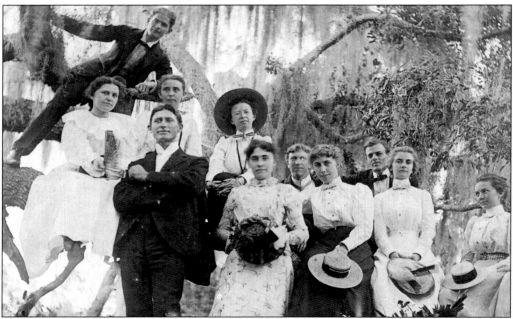

In 1899, members of prominent early Eustis families enjoy a picnic at Lake Saunders, one of Lake County's more than 1,400 lakes. In the tree are Ray Ferran, Kate Clifford, Mabel Bishop, and Grace Way. Standing are, from left to right, Ed Norton, Mera Hill, Laurie Taylor, Edith Smith, Harry Hoag, Mina Fuller, and Bertie Clifford. (Courtesy of the Lake County Historical Society and Museum.)

Eustis police chief Alfred Hammond is shown in this 1941 photograph, which appears to have been taken in Ferran Park. (Courtesy of the Lake County Historical Society and Museum.)

The Big Scrub and swamps in Lake County provided much needed hiding places for the manufacture of illegal moonshine. The two Eustis police officers shown in this 1952 photograph, Pink Lawrencson (left) and Chief Jimmy Dickerson, have made quite a haul. (Courtesy of Porter's.)

Pictured here is the much-loved Eustis Elementary schoolteacher Alice Church with her infant nephew William "Bill." Church lived with her family only a few blocks from the school where she taught more than two generations of students. Her father, William, came to Eustis in the 1880s and served as city treasurer. Her brother Seward, young Bill's father, managed William L. Church & Clock Repair. (Courtesy of the Lake County Historical Society and Museum.)

Raymond Slaven, a member of the Eustis High School senior guard, was awarded most valuable player with the Col. H.R.P. Miller trophy in 1936. Raymond was also selected for the Central Florida Conference team. Slaven was a founder of Eustis Little League baseball, officer for the Lake County Fair Grounds, and special officer and auxiliary officer in the 1950s for the Eustis Police Department.

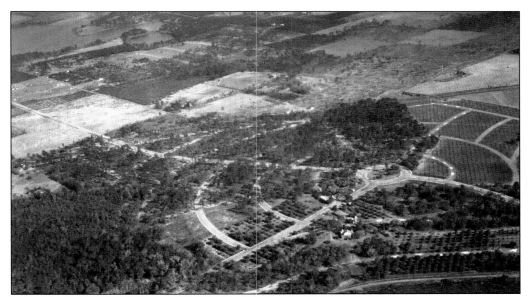

This 1940 aerial photograph shows Eustis Heights, the first planned community in Eustis. Laid out in a circular fashion, similar to Washington, DC, the subdivision is located on Clay Boulevard. It was advertised to be "the logical location for discriminating people who are seeking the ideal home site in Florida." Because of the Depression, that dream was not realized, and most of the property became grove and truck land for many years. (Courtesy of the Lake County Historical Society and Museum.)

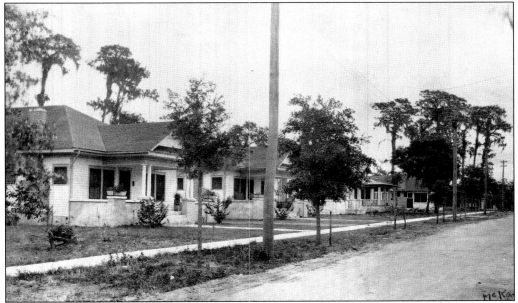

"Bungalow Row" on Washington Avenue is seen in a 1926 photograph depicting the diverse styles of early home development in Eustis. Eustis's first locally designated historic district, the Washington Avenue Historic District was dedicated in January 1998. The majority of the homes are of the Craftsman, Frame, Vernacular, Prairie, and Gothic Revival styles. (Courtesy of the Lake County Historical Society and Museum.)

Frank Waterman, shown here, was the owner and developer of the Fountain Inn Hotel. The Depression hit Eustis hard, and by 1936, the hotel was closed. After suffering a stroke, Waterman believed the old building would be ideal for a hospital. With the help of Dr. Chamber Tyre and other local doctors, it became the Lake County Medical Center in 1938.

Famed archaeologist Dr. Edgar Banks was Eustis's own Indiana Jones. In addition to his famous archaeological exploits, he opened Seminole Films Inc. in March 1923. The company produced educational film dramas, such as *Bacchus*. The studio was an independent filmmaker that prided itself on the accuracy of costuming and archaeological details. Banks is shown with his wife Minja, daughter Daphne, and son Edgar "Bobby" at their Lakeview Avenue home.

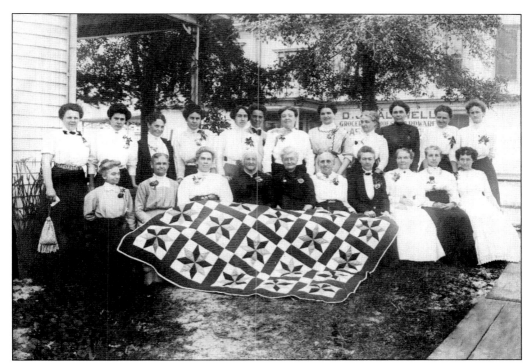

This 1912 photograph was taken at the corner of Bay Street and MacDonald Avenue in the front yard of the Eustis House and across the street from Caldwell's Store, formerly Clifford's. Partial identifications of quilters displaying their work include Mary Priscilla Bishop, Maryann Lapsley Bishop, Louise Porter, and Sallie Purvis Porter. (Courtesy of Clayton Bishop.)

Moses Jesup Taylor Jr. and his wife, Annie Barrington Taylor, were early settlers in Eustis. Moses was a government surveyor who came to the area on a mule after the Civil War. He was elected the first city clerk of Eustis. His son, Laurence Jesup Taylor, trained as a pharmacist and became owner of the Palm Pharmacy. Laurence J. Taylor Jr. inherited the business. The family still lives locally. (Courtesy of William and Susan Taylor.)

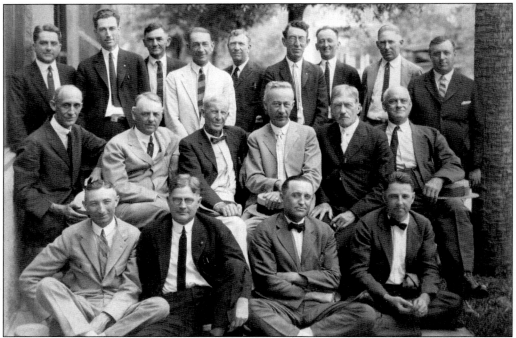

The 1924 Rotary Club is shown in this photograph. Those pictured are, from left to right, (first row) George Wheeler, Ray Ferran, Dr. Hannum, and Carl Ferran; (second row) Charles Isted, Will Igou, C.A. Child, ? Mattox, Dr. Samuel Moore, and John Nichols; (third row) Harry Ferran, Harran Hannah, George Pierce, Dr. Isaac Kennedy, Laurie Taylor, Ansil Miller, George Williams, Dolph Keene, and Clarence Williams.

Pictured at a 1956 city council meeting are, from left to right, Joe Kennedy, Leslie Huffstetler, Frank Stebbins, Jim Colgrove, Laurence Hughes, Ernest Kidd, Owen Kriegsman, Dr. Bill Furey, and Harold Hippler. (Courtesy of the Lake County Historical Society and Museum.)

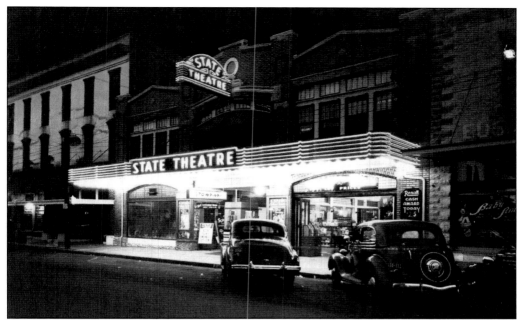

The State Theatre, built in 1922 at 109 North Bay Street in the Iron Block Building, is shown in this nighttime photograph from 1950. It began its life as a vaudeville house with live performances but was soon converted into a movie house. Abandoned for many years, it was renovated in 1975 and reopened as a live performance venue once more by the Bay Street Players.

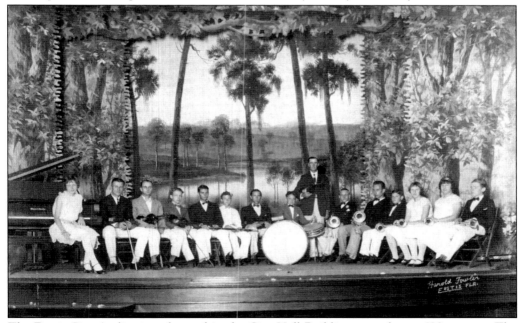

The Eustis City Auditorium, located in the City Hall Building, seated over 600 patrons. The hall was in the space that is now occupied by the commission room. The balcony space of the auditorium became the second floor of city hall. On stage in this photograph are Byron King and his music students. Two of the students are identified as Kenneth Glass and Jim Mulholland.

Barton Mumaw Jr., a featured solo dancer with the Ted Shawn Dancers, grew up in Eustis. At the age of 15, he became interested in the free express movement. He practiced daily on a rail, constructed by his father, on his back porch. Mumaw joined the Ted Shawn all-male dance team and performed worldwide. He received critical acclaim for his performance of *Pierrot in the Dead City* at the Lyric in Baltimore, Maryland. (Courtesy of the Lake County Historical Society and Museum.)

Ted Shawn, often called the "Father of Modern Dance," is shown at his Eustis lakeside home and training camp. Ted began his career in 1914 choreographing dances for vaudevilles with his wife, Ruth. He formed an all-male dance troupe of eight dancers, who performed some of his most controversial and skilled choreography in theaters such as the Lyric in Baltimore, Maryland. (Courtesy of the Lake County Historical Society and Museum.)

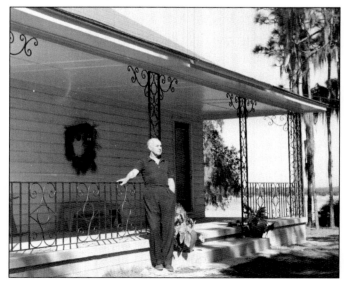

The Florida Sportsman Exposition was instituted in 1921 to provide a venue for the residents to compete on a local level with their crafts, gardening, cooking, baking, and livestock. As the weeklong exposition grew, its name was changed to the Lake County Fair. The fair continues to draw large crowds each spring.

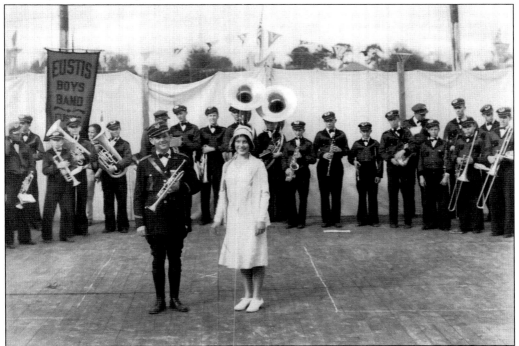

Florence Smock, a 1929 National Health champion of the United States, makes her debut at a ceremony and is introduced by Capt. Jimmy O'Neal, the director of the Eustis Boys Band. Florence, at age 17, was selected from over 720,000 4-H Club members at the National 4-H Club congress in Chicago, Illinois, as the healthiest girl in America.

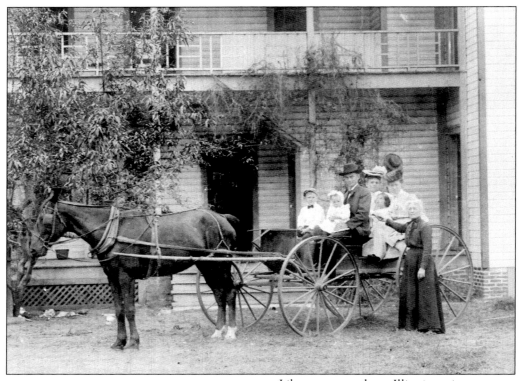

Like so many others, Illinois natives Richard and Helen Haselton first came to Eustis as winter visitors and then as permanent residents in 1893. Attracted by the warmer climate, they built a home, the "Pines," between Haselton and Fahnstock Avenues, shown here shortly after completion. The woman standing at the rear of the buggy is Helen Marie Curtis Haselton, the mother of Stinson and grandmother of Jean, Donald, and Thomas. (Courtesy of the Lake County Historical Society and Museum.)

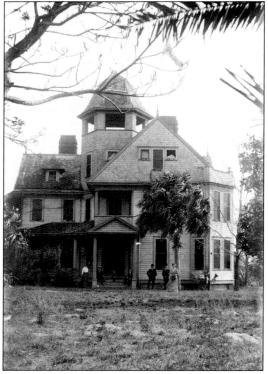

The Palms is a Queen Anne–style, Victorian home designed and built by William Pendleton, the pastor of the First Presbyterian Church. Built on Lakeview Avenue, it had 14 rooms, each with a fireplace. The house served as a retreat for visiting ministers who lived off the land by hunting, fishing, and cultivating citrus fruit. It is still used as a residence. (Courtesy of Porter's.)

Edgar L. Ferran (center), shown with his four sons, from left to right, Ray, Carl, Harry, and Clarence, arrived in Eustis in 1883. He came from Indiana looking for a healthier place to raise his family. He opened a store on Bay Street, along with partners W.M. and M.R. Moore. In 1896, he became the sole owner after enlarging a brick building at the corner of Bay Street and Magnolia Avenue. Later, his sons joined the business as partners, but he remained president until his death in 1923. Among his many accomplishments were city councilman, city treasurer, board of trade president, and editor of the *Eustis Lake Region* newspaper. Associated with every improvement movement for Eustis and Lake County, Ferran's fellow citizens named the waterfront park on Lake Eustis in his honor. Shown below is his home on Orange Avenue.

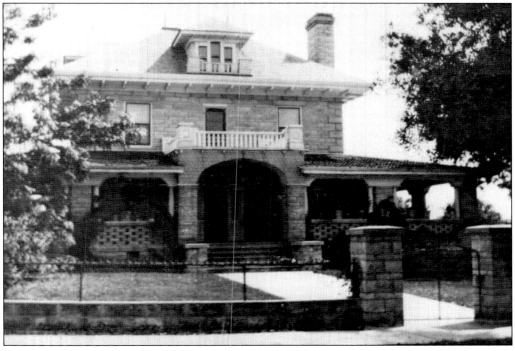

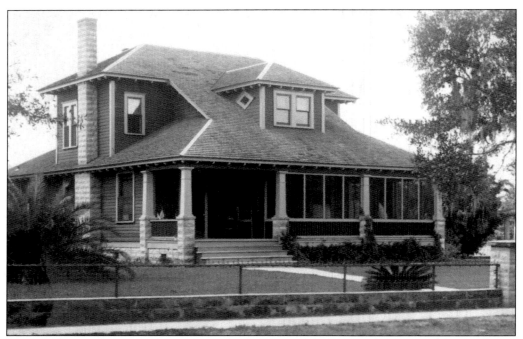

The 1924 home of Harry L. Ferran, located at 310 Orange Avenue on the corner of Center Street, was next to his father's home. The family later sold it to the Zeller, Kennedy, Hamlin, and Hilbish Funeral Home, which remodeled it.

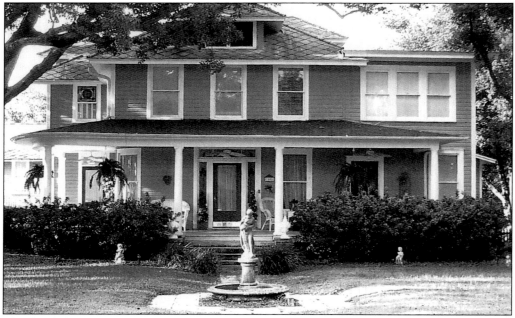

This lovely home in the Washington Avenue Historic District was built in 1923 for the Dillard family. The family was active in the early development of Eustis and involved in the citrus and agricultural industries. Murrell Dillard, who lived in the home, was killed during World War II when his plane went down in Europe. Members of the Dillard family still live in the house today.

Eustis mayor Frank Stebbins congratulates C. Harold Hippler. After 25 years as Eustis city attorney, Hippler became city attorney for Umatilla. The City of Eustis elected him honorary city attorney, which was an unusual honor. (Courtesy of the Lake County Historical Society and Museum.)

Willis V. McCall (1909–1994) is shown in a photograph taken during his first year as Lake County sheriff. McCall had an illustrious, and very often controversial, career in this post, serving seven consecutive terms from 1944 until he lost the running for an eighth term in 1972. Infamous as a segregationist, several events during his career made national headlines.

Mary Jane Prescott Hogan, a 1911 graduate of Eustis High School, served in the US Naval Reserve Force from 1914 to 1918 during World War I. She was honorably discharged, having attained the rank of Yeoman First Class. (Courtesy of Mary Jane Prescott Hogan's niece Geraldine Rouveyrol.)

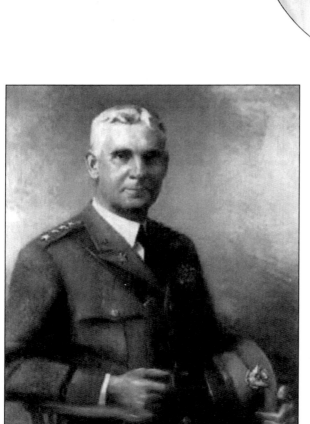

Gen. Charles Pelot Summerall (March 4, 1867–May 14, 1955) fought in World War I, was Army chief of staff between 1926 and 1930, and was president of The Citadel, a military college in South Carolina, between 1931 and 1953. His father T. Bryans assisted in the incorporation of Eustis and he thought of Eustis as his home. Charles returned there to teach school after he completed college and before going into the Army.

Shown inside Merry Jewelers on Magnolia Avenue, from left to right, are Nat McGarity of Ferran's Department Store, George Warren of Bay Pharmacy, and Merry Jewelers owner Smiley Merry. The men are "Celebrating Hatchet Days-Chopping Prices," a special sale held on February 22.

Lottie Clifford Taylor, the daughter of Eustis pioneer Guilford Clifford, is shown celebrating her 100th birthday in 1972. Taylor, who grew up in the Clifford family home, sold the house to the city for use as the Eustis Historical Museum and Preservation Society. Today, the house is listed in the National Register of Historic Places and serves as the headquarters for the organization and as a public museum.

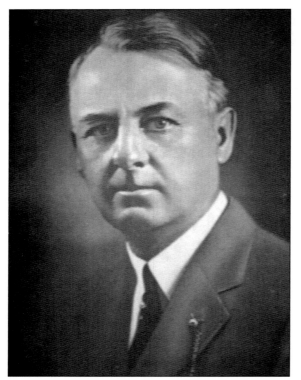

Sen. William F. Igou moved to Eustis in 1906. He opened W.M. Igou Inc., which handled mules, feeds, fertilizers, wagons, harnesses, and machinery. He also owned groves and was active in civic organizations. His political career included positions in county and state government and 14 years as a state senator. He became Florida's secretary of state but had to resign due to poor health.

Well-known local artist Catherine Haynes Stockwell lived in Eustis most of her life. Her earliest works are done in post-impressionist style and are moody, with a darker palette and greater detail than her later works. Her favorite subjects were views of Alexander Springs, Lake Eustis, Trout Run, the Dora Canal, and the local black community. The Eustis Historical Museum has a collection of her early paintings on permanent display.

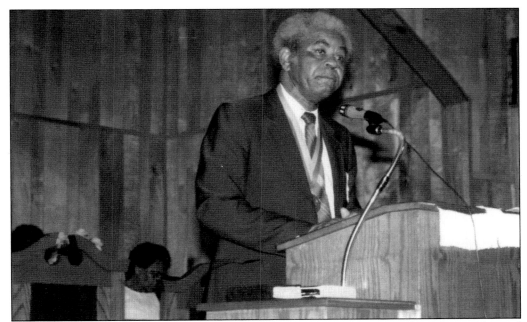

Thomas H. Poole was a teacher and football coach at Curtwright High School from 1951 until 1954. He started the football program, which played its games at Eustis High School on Thursday evenings. He served as president of the Florida NAACP for 10 years and remained active in the organization for many more years.

Silver Throne Everlasting Pinkney, known to all as STEP, devoted educator and civic leader, came to Eustis in 1948 from nearby Kissimmee to become principal of Eustis Vocational High School. He later became Coordinator of Lake County Schools Migrant Program, which bears his name (STEP Program). He was the first black mayor of Eustis, serving four terms, as well as 14 years as city commissioner.

Capt. David Walker was raised in Eustis and was a 1962 graduate of Eustis High School. He graduated from the US Naval Academy and became a Navy test pilot and a combat pilot in Vietnam with 7,500 flying hours. In 1978, he was selected as an astronaut with NASA, logging over 724 hours in space on four flights as pilot and three as commander. Captain Walker died of cancer in April 2001. (Courtesy of the Lake County Historical Society and Museum.)

Lt. George Cox of Eustis is shown here with Genevieve Coggshall and Edna Lane Shaw as they accept the uniform worn by Lieutenant Cox on the flight to recover astronaut Alan Shephard. A luncheon held at the Fountain Inn Hotel on July 18, 1961, commemorated the donation of his uniform to the Lake County Historical Society. The uniform is on display at the Eustis Historical Museum.

About the Organization

The Eustis Historical Museum and Preservation Society Inc. governs and oversees the operation of the Eustis Historical Museum, located in the historic Clifford House, built in 1910–1911. The Society strives to expand their efforts to successfully implement the mission statement of the museum:

"The mission of this museum is to unite and utilize the combined efforts, talents and resources of the members to collect, preserve and display historical, cultural, educational artifacts pertaining to Eustis, Lake County, and the State of Florida, and conduct educational programs for the general public."

The Eustis Historic Museum, a 501c3 nonprofit organization, relies on memberships, grants, donations, fundraisers, and assistance from the City of Eustis to maintain the museum for future generations.

DISCOVER THOUSANDS OF LOCAL HISTORY BOOKS FEATURING MILLIONS OF VINTAGE IMAGES

Arcadia Publishing, the leading local history publisher in the United States, is committed to making history accessible and meaningful through publishing books that celebrate and preserve the heritage of America's people and places.

Find more books like this at
www.arcadiapublishing.com

Search for your hometown history, your old stomping grounds, and even your favorite sports team.